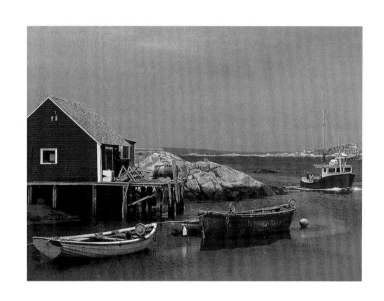

NOVA SCOTIA

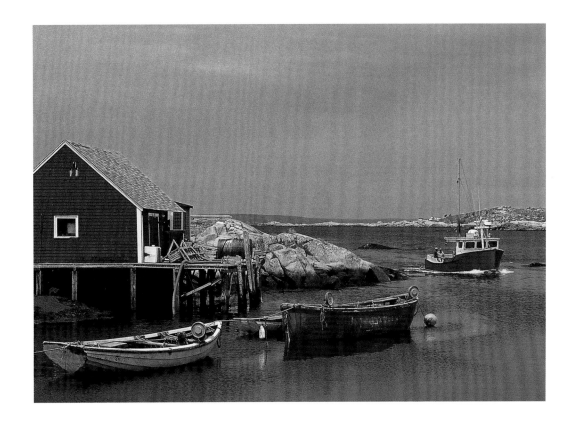

WHITECAP BOOKS

The information in this book is true and complete to the best of our knowledge. All
recommendations are made without guarantee on the part of the author or Whitecap
Books Ltd. The author and publisher disclaim any liability in connection with the use
of this information. For additional information please contact Whitecap Books Ltd.,
351 Lynn Avenue, North Vancouver, British Columbia, Canada, V7J 2C4.

Text by Tanya Lloyd Kyi
Edited by Elaine Jones
Photo editing by Tanya Lloyd Kyi
Proofread by Lisa Collins
Cover and interior layout by Jacqui Thomas

Printed and bound in Canada

National Library of Canada Cataloguing in Publication Data

Kyi, Tanya Lloyd, 1973–
 Nova Scotia/Tanya Lloyd Kyi

 (Canada series)
 ISBN 1-55285-418-3

 1. Nova Scotia—Pictorial works. I. Title. II. Series: Kyi, Tanya Lloyd, 1973–
Canada series.
FC2312.K94 2003 971.6'04'0222 C2002-911395-4
F1037.8.K94 2003

The publisher acknowledges the financial support of the Government of Canada through
the Book Publishing Industry Development Program for our publishing activities.

For more information on the Canada Series and other Whitecap Books
titles, please visit our web site at www.whitecap.ca.

Nova Scotia is only 560 kilometres (350 miles) long and no point of land is more than 56 kilometres (35 miles) from the sea. Despite its diminutive size, the province is rich in diversity, each region steeped in a distinct heritage.

Historians believe that when John Cabot sailed the coast in 1497, Nova Scotia was home to 25,000 Mi'kmaq people. Within a few centuries, colonists were drastically changing the character of the region. In the northern outposts and on Cape Breton Island, it was Scottish settlers who arrived to farm along the jagged coastline, naming their chosen land Nova Scotia — New Scotland — because it reminded them of the rugged, foggy beauty of home. At Louisbourg, French fishers landed to dry their catch on the beaches and slowly built a town, then a fortress. To the southwest in the Annapolis Valley, French farmers called Acadians created farms from fertile floodplains. Loyalists, British soldiers, Irish farmers, and other immigrants from around the world soon followed.

By Confederation on July 1, 1867, when Nova Scotia became one of the four original provinces of Canada, these disparate strands had already begun to meld and become what we know today as the Maritimes culture. Scottish tartans and fiddle tunes, French croplands, and the unique dialects of the isolated fishing villages are now part of what attracts about two million visitors each year.

Some of these sightseers flock to the busy streets and hip nightlife of Halifax, home to almost half of Nova Scotia's residents. Others travel beyond the harbour boardwalk, beyond the famous views of Peggy's Cove, to visit more isolated sites along the province's 7,400 kilometres (4,600 miles) of coastline. On the shores of the Atlantic Ocean, the Bay of Fundy, the Northumberland Strait, and the Gulf of St. Lawrence, tiny communities rich in history and culture offer a hospitable Maritimes welcome.

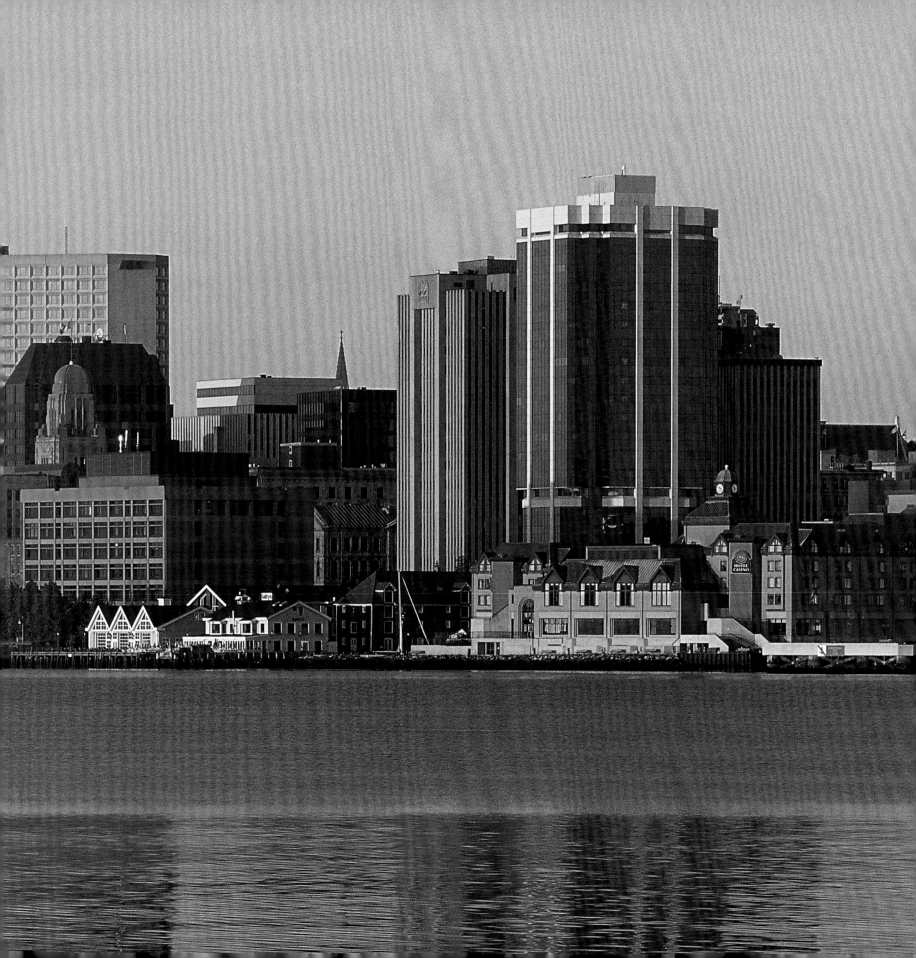

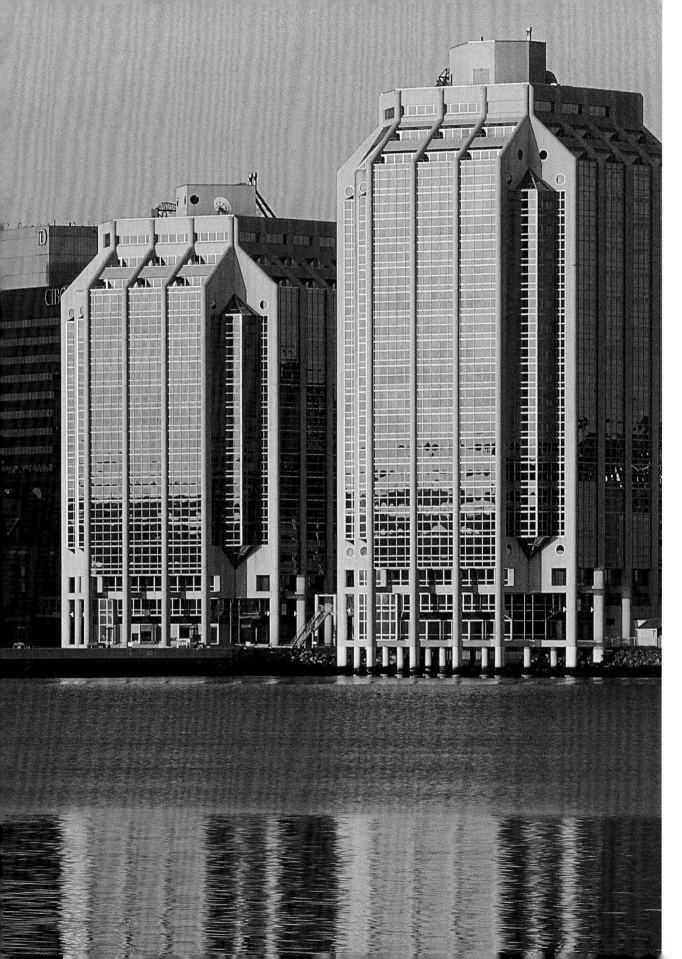

Built on the edge of the world's second-largest natural ice-free harbour, Nova Scotia's capital city has welcomed merchants and visitors from around the world since it was founded by the British in 1749. Greater Halifax is now home to 360,000 people—40 percent of Nova Scotia residents.

A waterfront boardwalk
leads Halifax visitors
past trinket shops,
upscale boutiques,
sidewalk cafés, and Old
World–style pubs. The
city is known for a
vibrant atmosphere and
a thriving entertainment
scene that grows espe-
cially lively after dark.

8

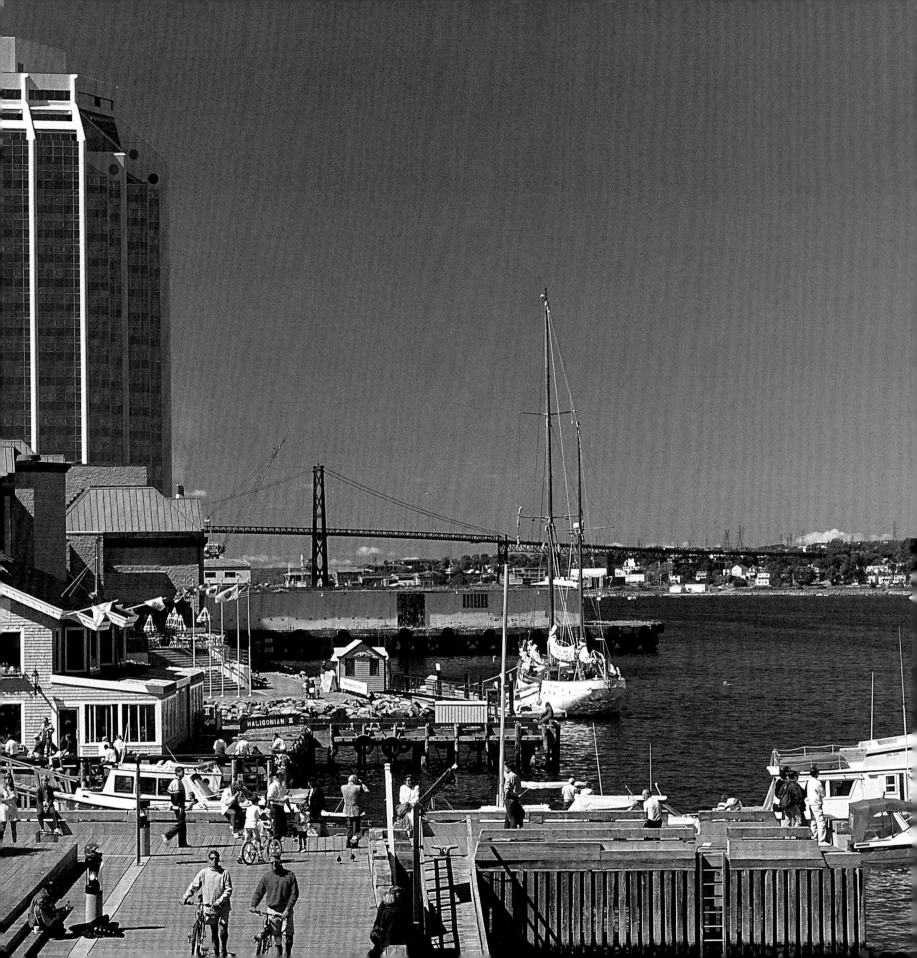

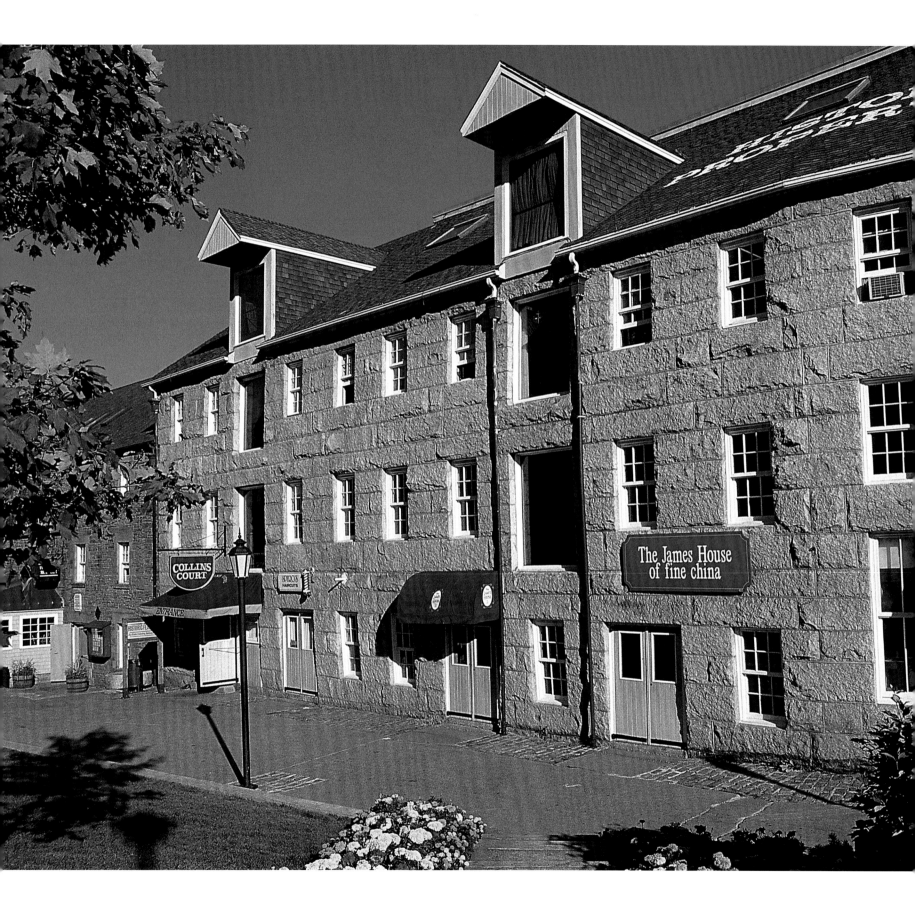

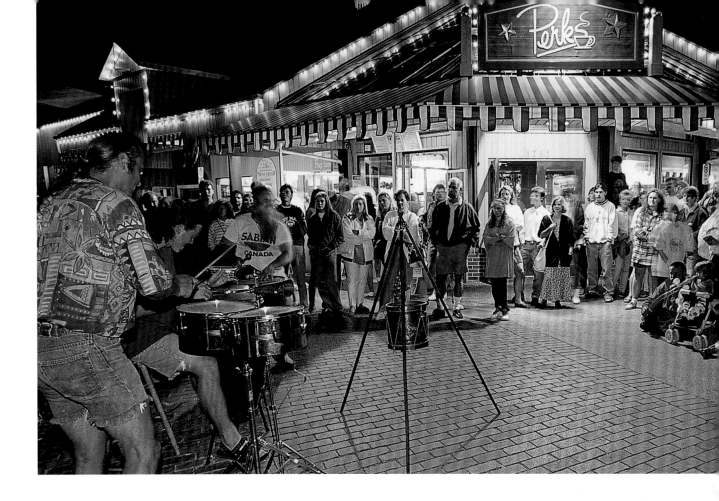

Summer draws comedians, mimes, dancers, musicians, and magicians from around the world to the city's waterfront for the Halifax International Busker Festival. Hundreds of performers apply, and festival organizers choose the best 25 to 30 acts to wow the crowds each year.

Two centuries ago, merchants, navy officers, and pirates rubbed shoulders on Halifax's waterfront streets. The Historic Properties—a collection of nineteenth-century warehouses preserved from the city's rough and ready past—today house specialty shops, restaurants, and nightclubs.

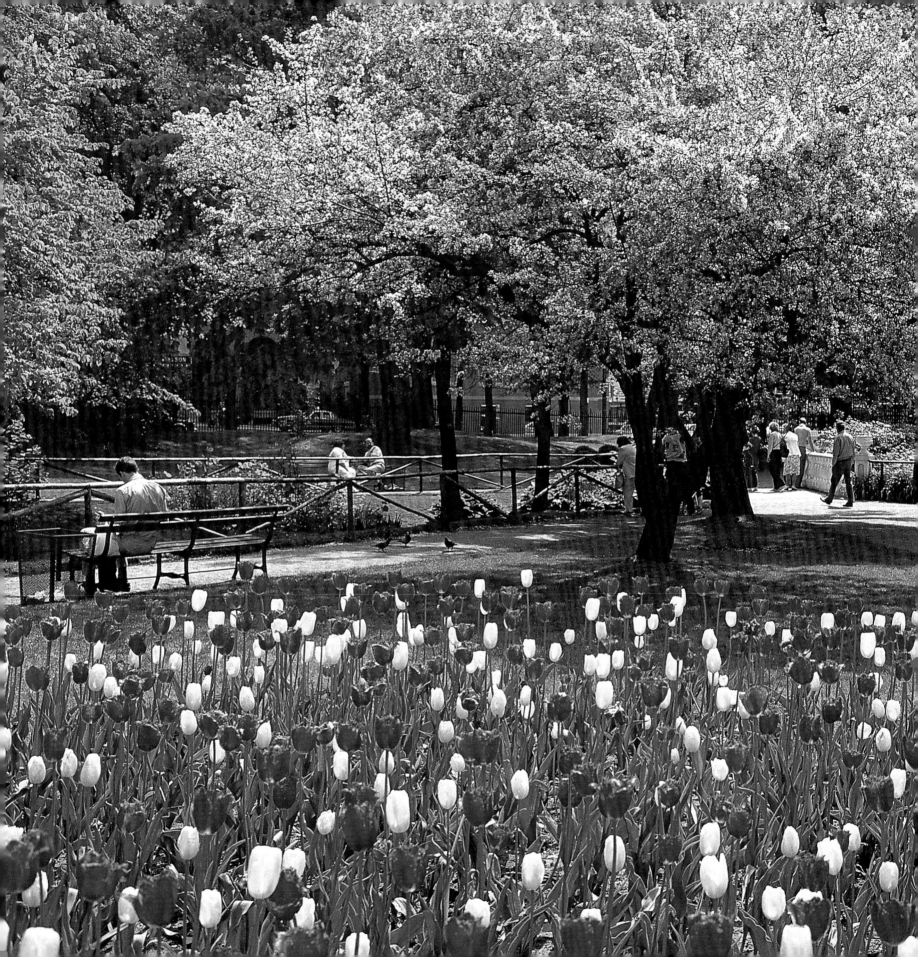

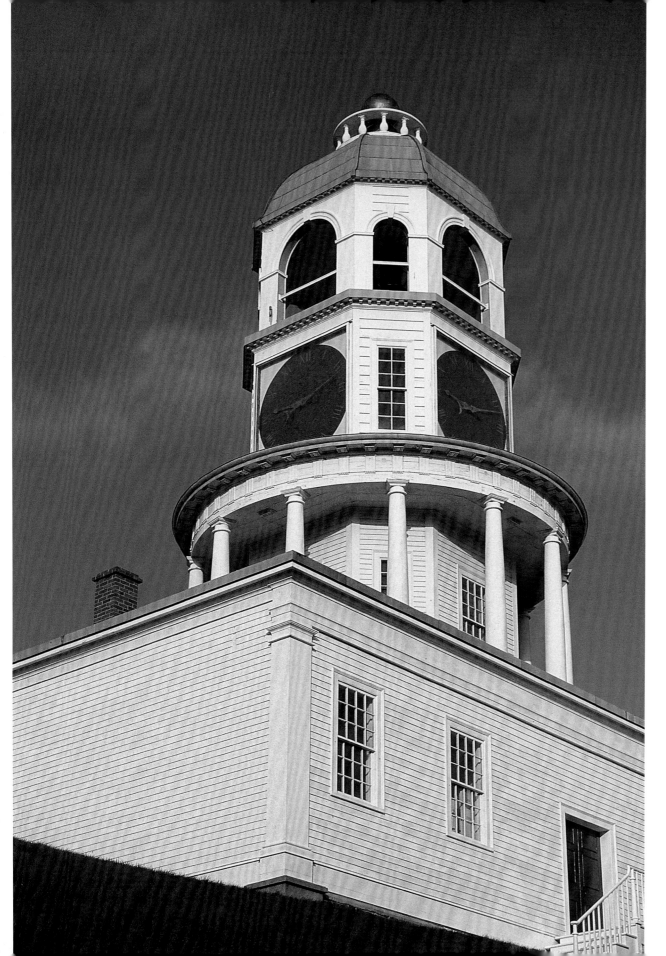

Prince Edward, Duke of Kent, commissioned the Old Town Clock in 1800. Created by the House of Vulliamy in London, the clock began keeping time for soldiers and city residents in 1803. Hidden within the building is a 4-metre (13-foot) pendulum, which has now been reliably swinging for more than two centuries.

FACING PAGE
The Halifax Public Gardens were originally begun by the city's horticultural club in the 1830s, to display botanical specimens, demonstrate gardening techniques, and provide enjoyment for local residents. The land was sold to the city in 1874, but some of the formal plantings remain as they were in Victorian times.

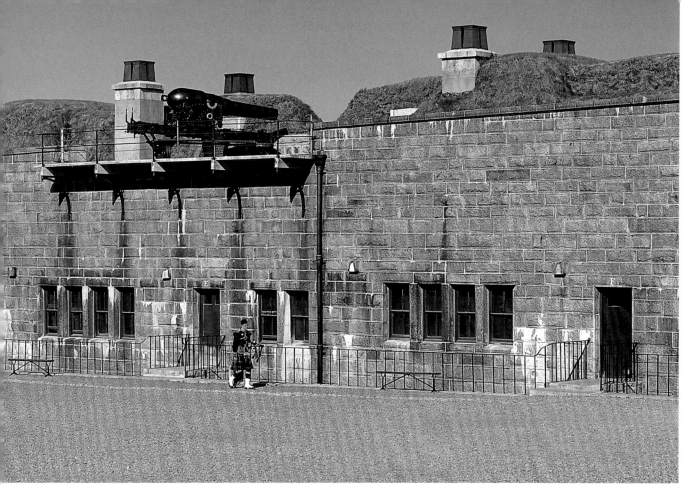

The ramparts of the Halifax Citadel National Historic Site stand stern and imposing. Built by the British in 1856 to replace earlier fortifications, the Citadel was designed to protect the city's port from invasion. Though it was never attacked, the fort remained in use by British and Canadian troops until World War II.

Parts of Halifax were destroyed in 1917, when a Belgian ship collided with a French vessel heavily laden with explosives. The harbour blast killed more than 1,900 people. Until the invention of nuclear weapons, the explosion was the largest man-made detonation in history.

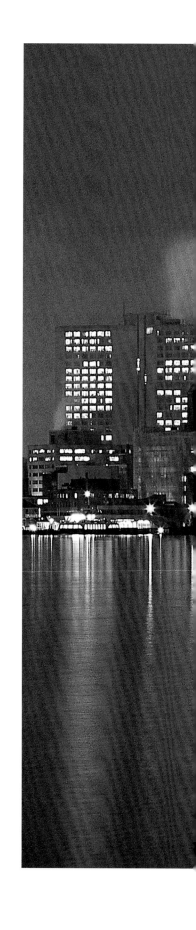

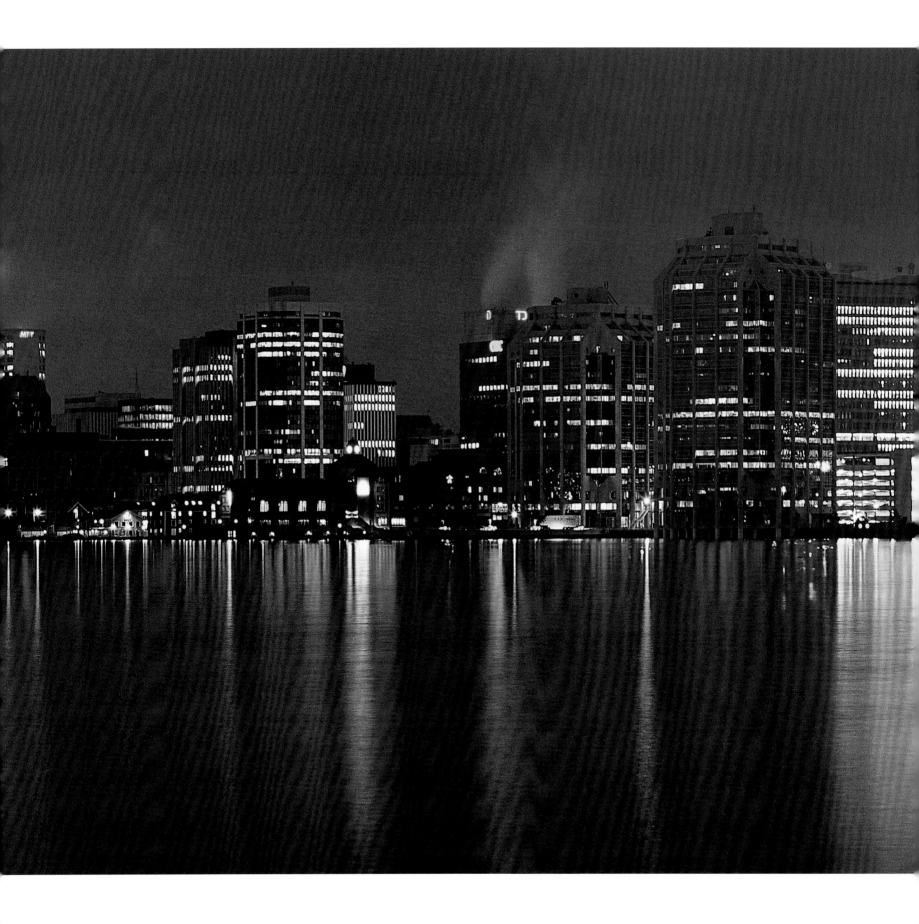

During World War II, British convoys of more than 100 ships gathered in Halifax's harbour, protected from the dreaded German U-boats by submarine nets stretched across the bay. Today the city's port handles about 14 million tonnes (14 million tons) of cargo each year, a quantity surpassed only by Montreal and Vancouver—both much larger cities.

OVERLEAF
Built in 1955 to link Halifax and Dartmouth, Angus L. Macdonald Bridge is a suspension bridge spanning 1.3 kilometres (.8 miles). Each overhead cable weighs 430 tonnes (475 tons). Together, they support steel, concrete, and vehicles weighing about 7,260 tonnes (8,000 tons). The bridge is named for a former premier.

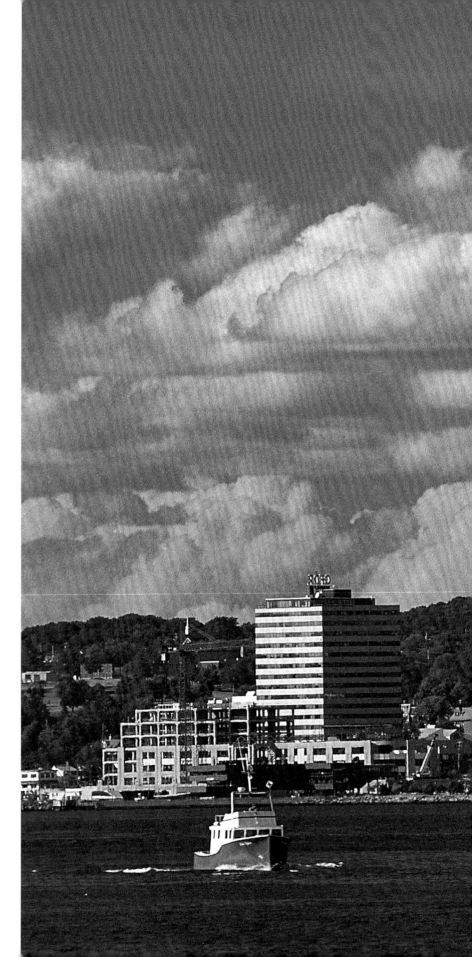

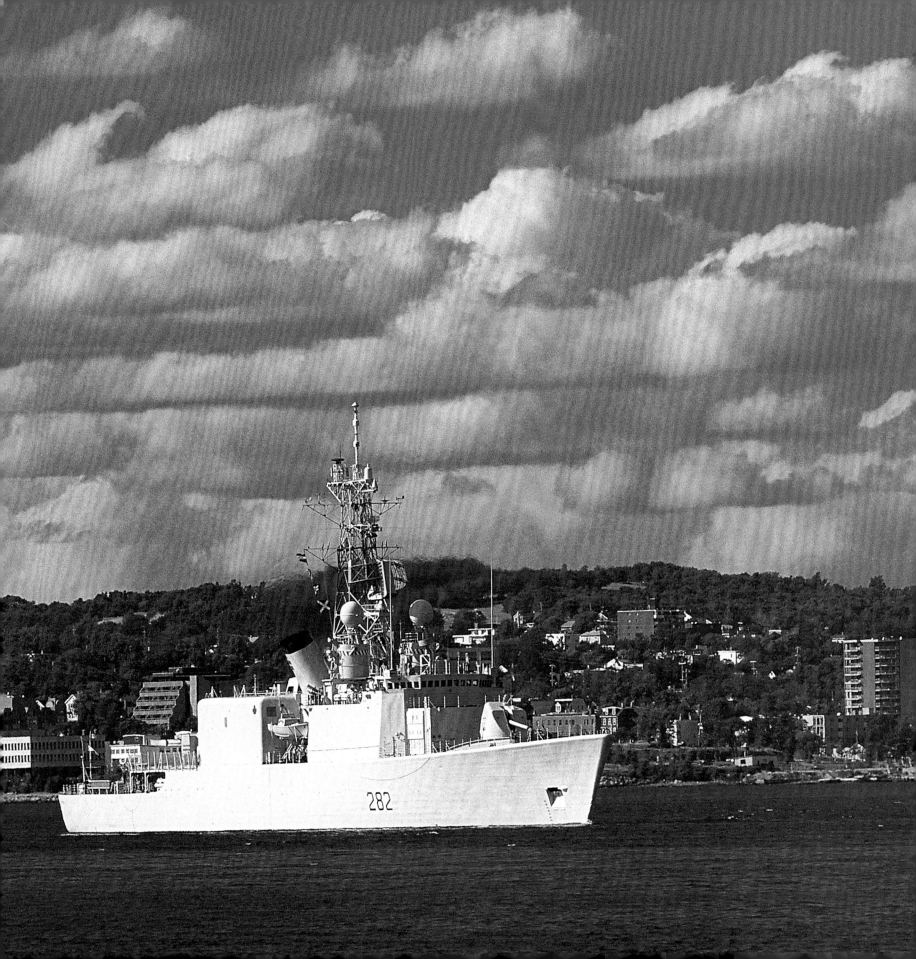

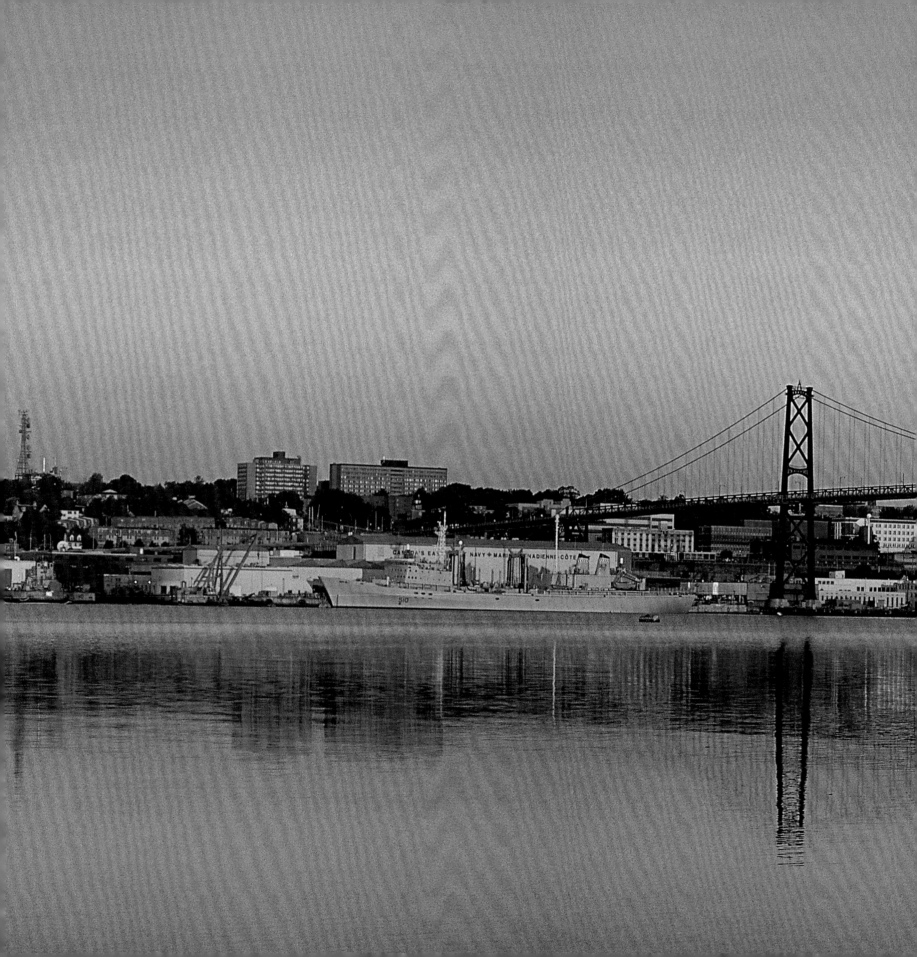

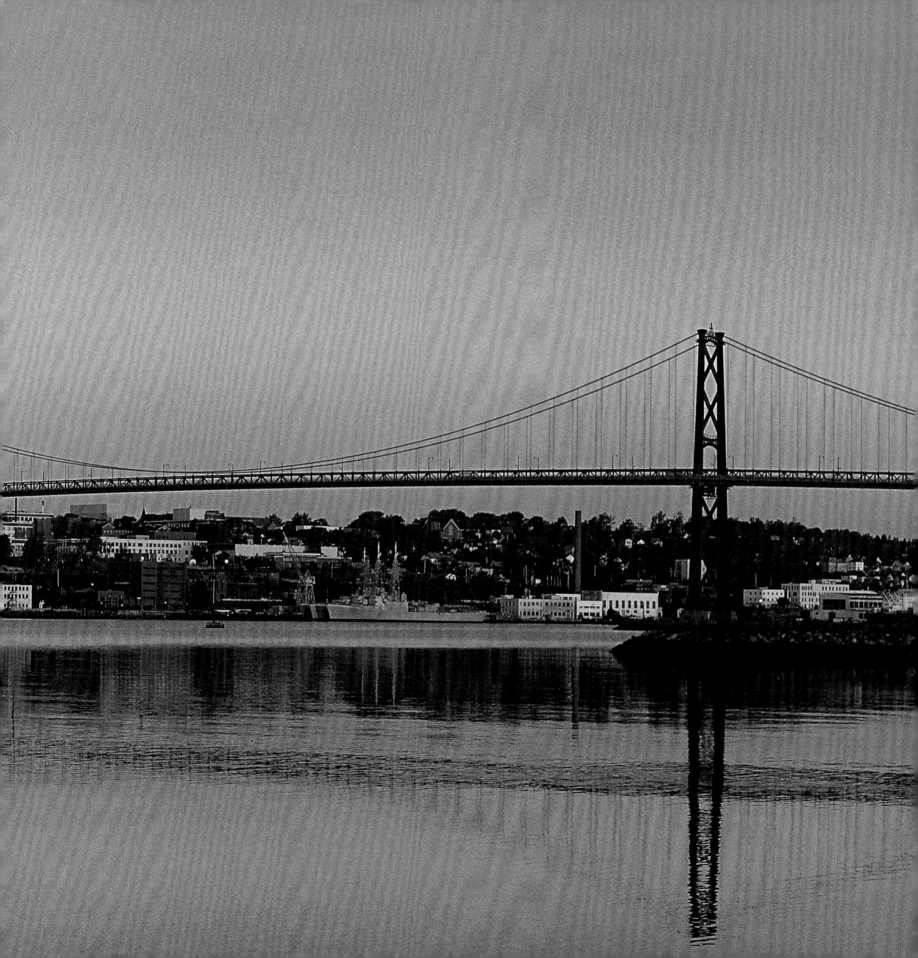

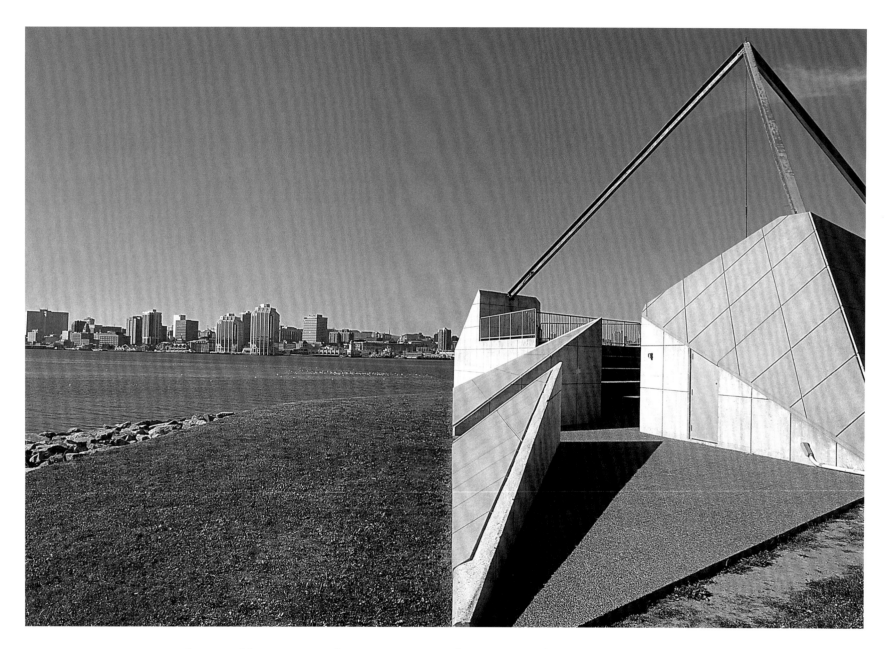

The World Peace Pavilion in Dartmouth was unveiled by Russian president Boris Yeltsin in 1995, during a G–7 economic summit. The pavilion was created using stones and bricks from more than 70 countries, based on the ideas of a local youth organization. It stands near the waterfront, offering visitors a panoramic view of the Halifax skyline.

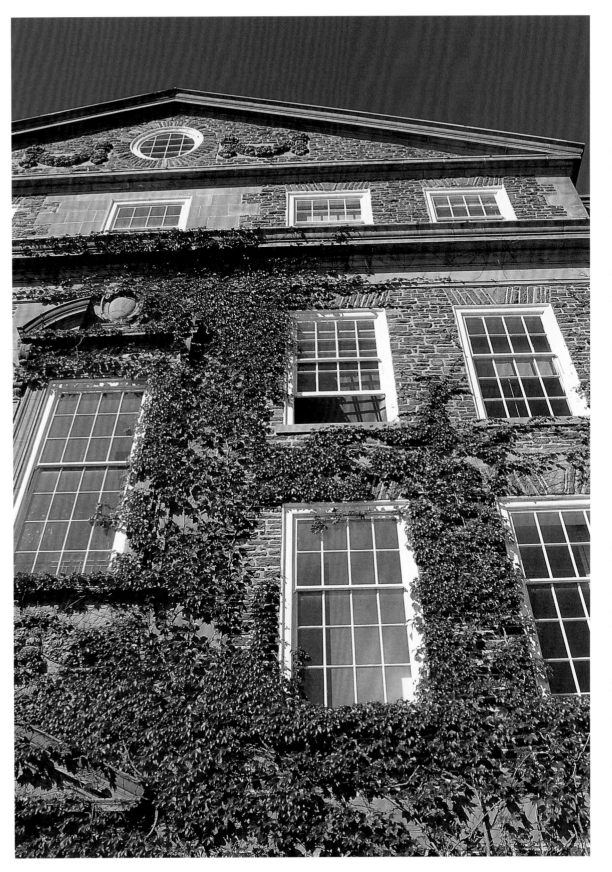

With spoils seized from American privateers during the War of 1812, George Ramsay (the lieutenant-governor of Nova Scotia and the 9th Earl of Dalhousie) founded a college in Halifax. He envisioned a school of religious tolerance, where people of any class were welcome. Almost two centuries later, Dalhousie University serves 13,500 students in 125 degree programs.

Overleaf
Built in 1915 to replace an earlier wooden tower, Peggy's Point Lighthouse marks the eastern entrance to St. Margaret's Bay. Inside, the only Canadian post office housed within a lighthouse gives visitors a chance to mail their postcards, complete with a lighthouse-shaped cancellation stamp.

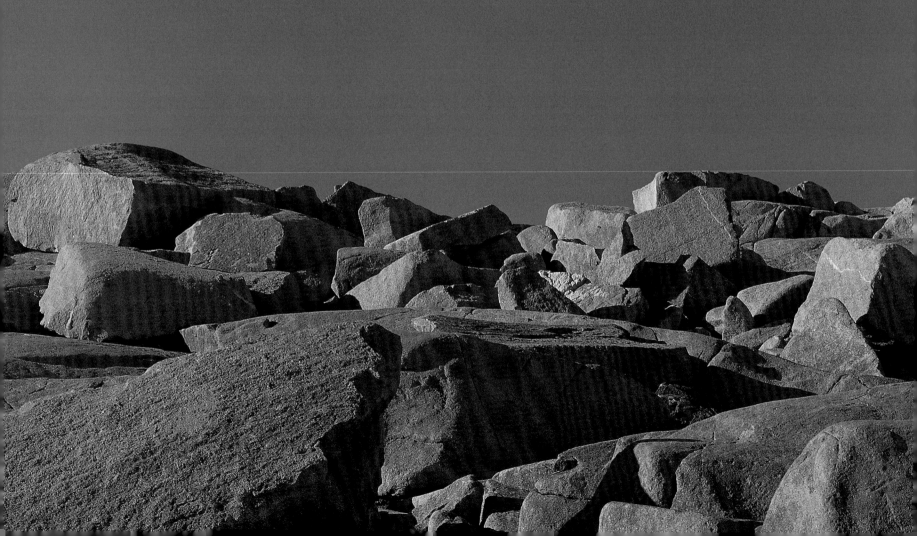

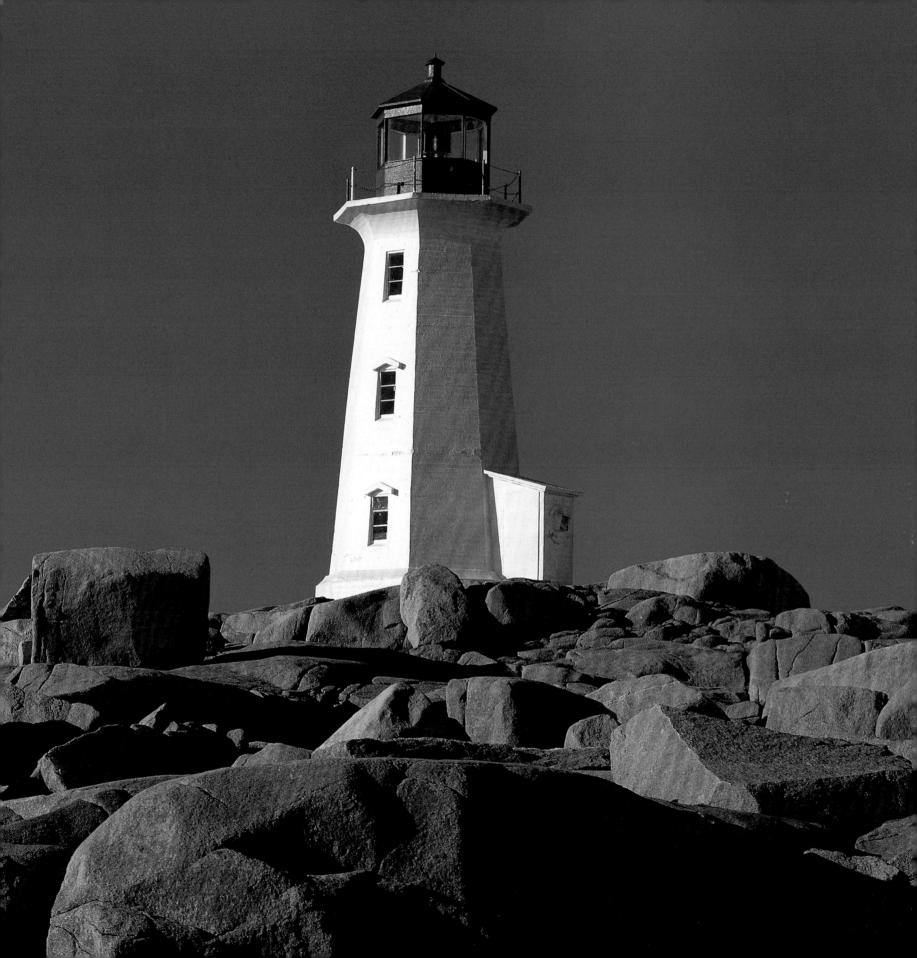

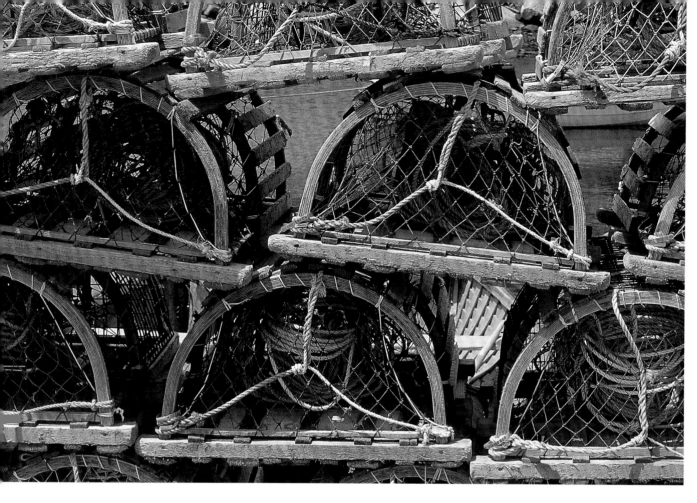

The lobster traps used throughout Nova Scotia are made of wood and metal, based on those invented in Cape Cod in the early 1800s. Bait in the front of the trap—the kitchen—entices the lobster. The creature is then led into the back, or parlour, section, where small vents trap large lobsters but allow the smaller ones to escape.

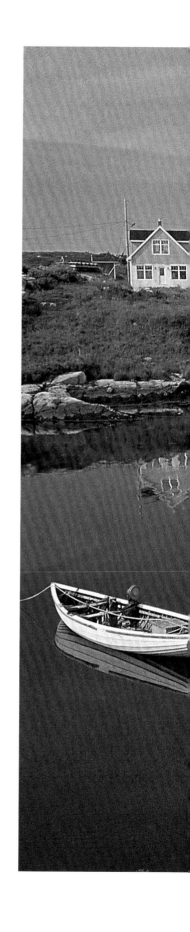

Founded in 1811, picturesque Peggy's Cove has become one of the most photographed places in Canada. According to local legend, Peggy's Cove is named for the only survivor of a nineteenth-century shipwreck off the rocky coast. Others believe the cove's name is drawn from nearby St. Margaret's Bay—Peggy is a traditional nickname for Margaret.

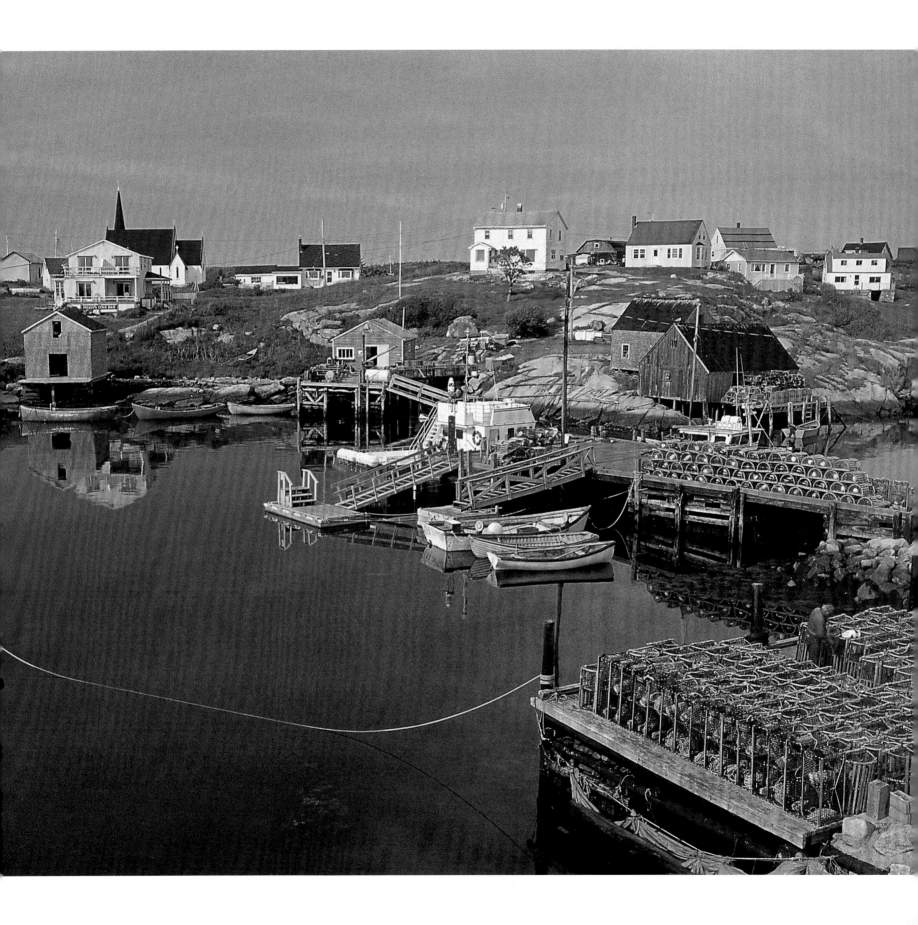

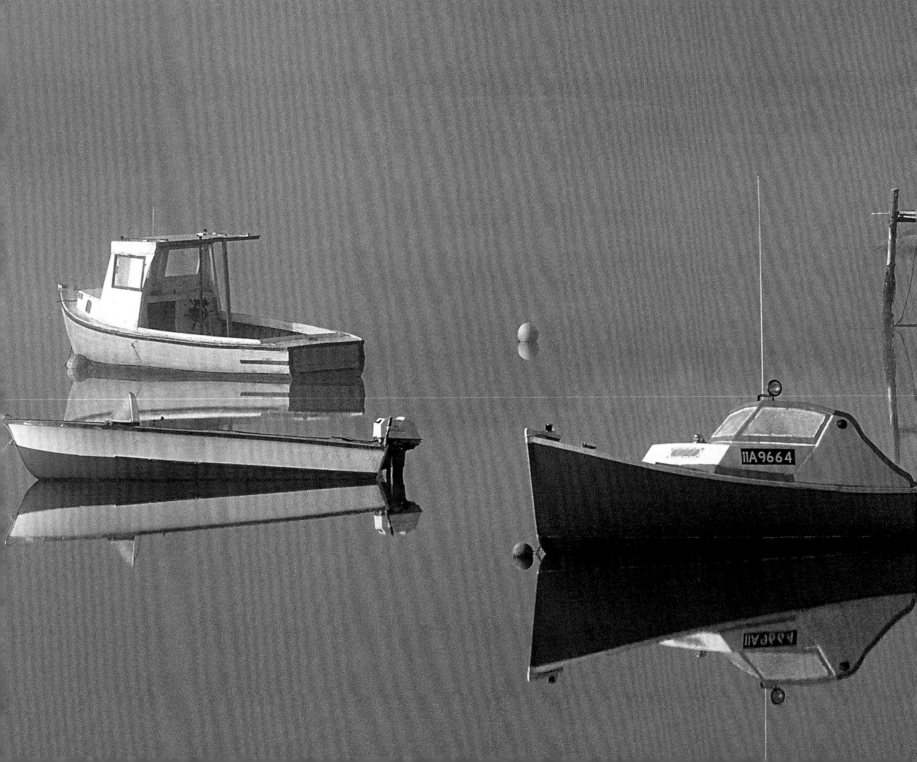

The Great Scarecrow Festival and Antique Fair draws crowds each fall to Mahone Bay, where stuffed and tufted specimens decorate homes, businesses, and streets. The celebrations also include musical performances, a pumpkin display and sale, a graveyard tour, street vendors, and a car show.

FACING PAGE
West Dover, just minutes away from Peggy's Cove, bears witness to Nova Scotia's seafaring past. The first residents of this area were the Mi'kmaq people, who survived on the sea's bounty for thousands of years. The first Europeans to settle the coastline were fishers from France, who established villages where they could rest and dry their catch before re-crossing the Atlantic.

Settled in the mid-1700s by fishers, farmers, and shipbuilders, Lunenburg was the first British settlement in Nova Scotia outside of Halifax. The town is home to various marine and shipping companies, along with High Liner Foods, one of the largest fish-processing plants on the continent.

From a tank where visitors can touch tiny sea creatures to a fisherman's memorial, a historic schooner, and a scallop-shucking house, the Fisheries Museum of the Atlantic explores many aspects of life on the sea. The museum is housed in a former fish-processing plant at the water's edge in Lunenburg.

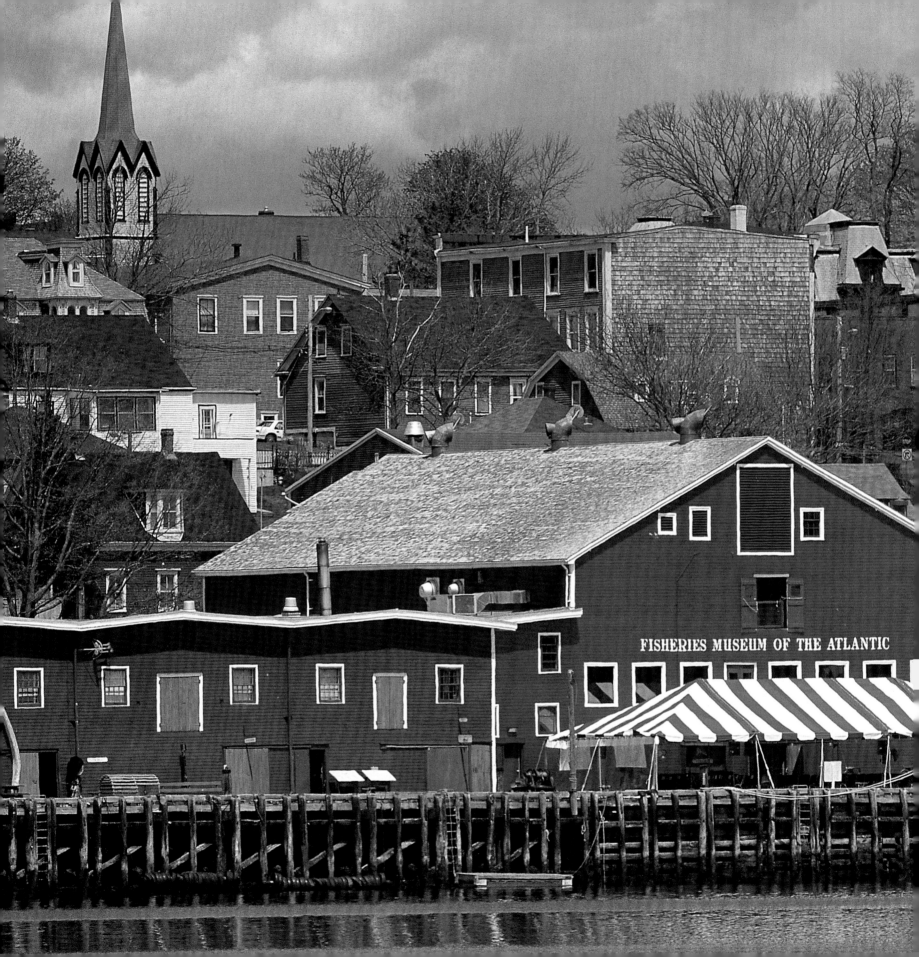

FISHERIES MUSEUM OF THE ATLANTIC

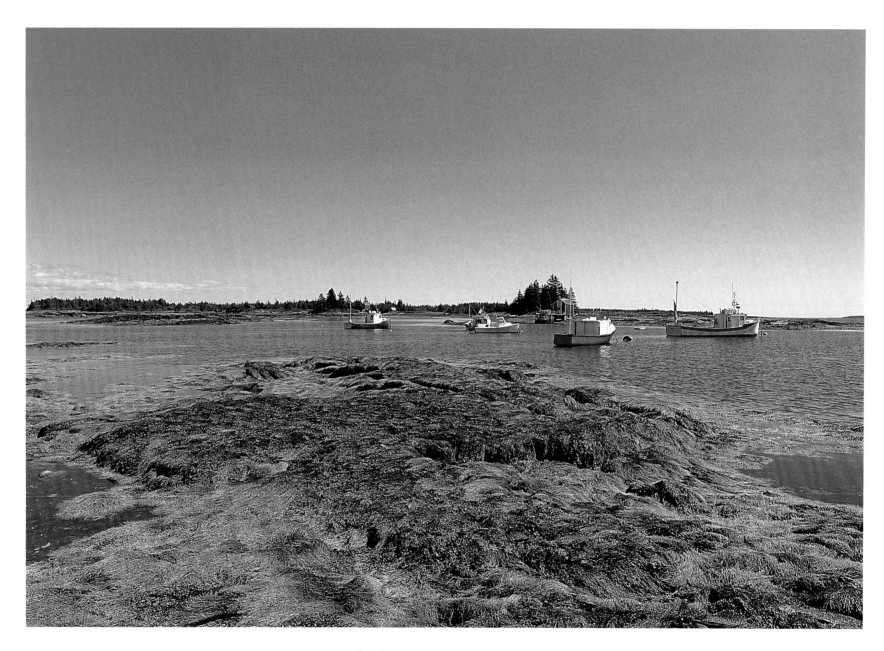

Nova Scotia visitors find quiet days, crisp sea breezes, quaint seaside cottages and bed-and-breakfasts in Blue Rocks, near Lunenburg. Guests looking for more excitement can explore the region's cycling, horseback riding, kayaking, and scuba-diving opportunities.

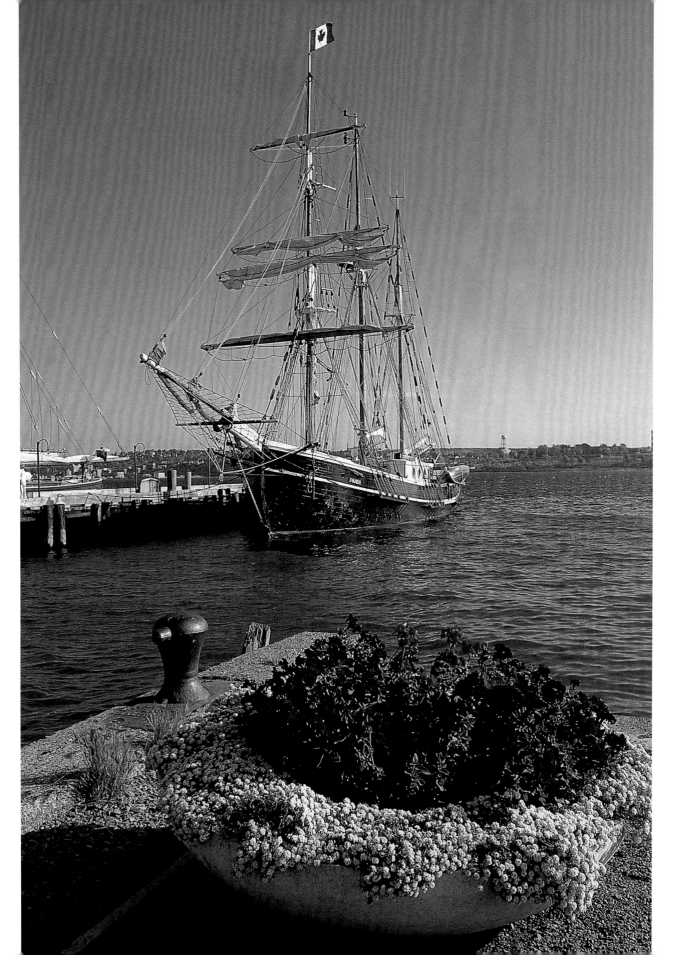

Nova Scotia's ship-builder's began designing yachts and racing schooners almost two centuries ago, basing some of their creations on the fishing schooners of the province's past. The world's oldest yacht club, the Royal Nova Scotia Yacht Squadron, was founded in Halifax in 1837.

31

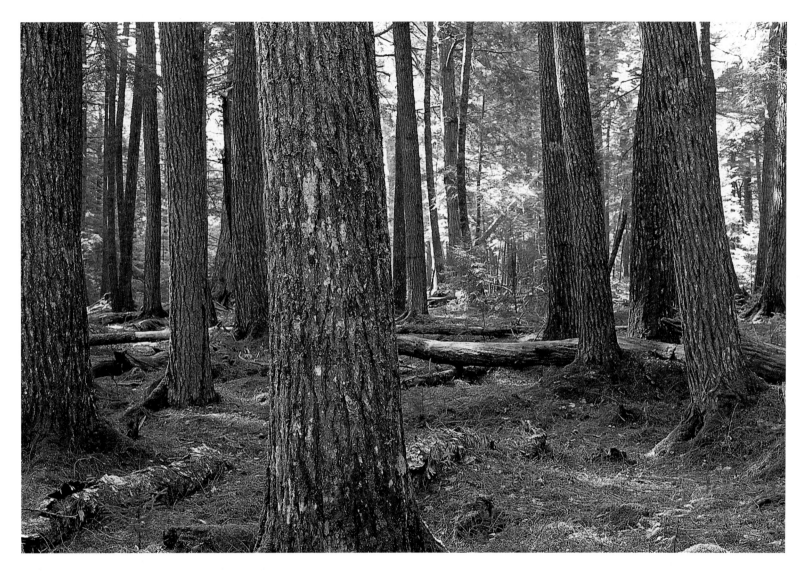

Encompassing 381 square kilometres (150 square miles) of inland wilderness, Kejimkujik National Park is home to black bears, white-tailed deer, bobcats, moose, foxes, porcupines, and several threatened species, including southern flying squirrels and northern ribbon snakes.

For more than 4,000 years before the arrival of European settlers, early inhabitants known as the Maritime Archaic people travelled canoe routes through what is now Kejimkujik National Park, on their journeys between the Bay of Fundy and Nova Scotia's Atlantic coast. Preserved campsites and pictographs also testify to the lives of Mi'kmaq and Woodland peoples.

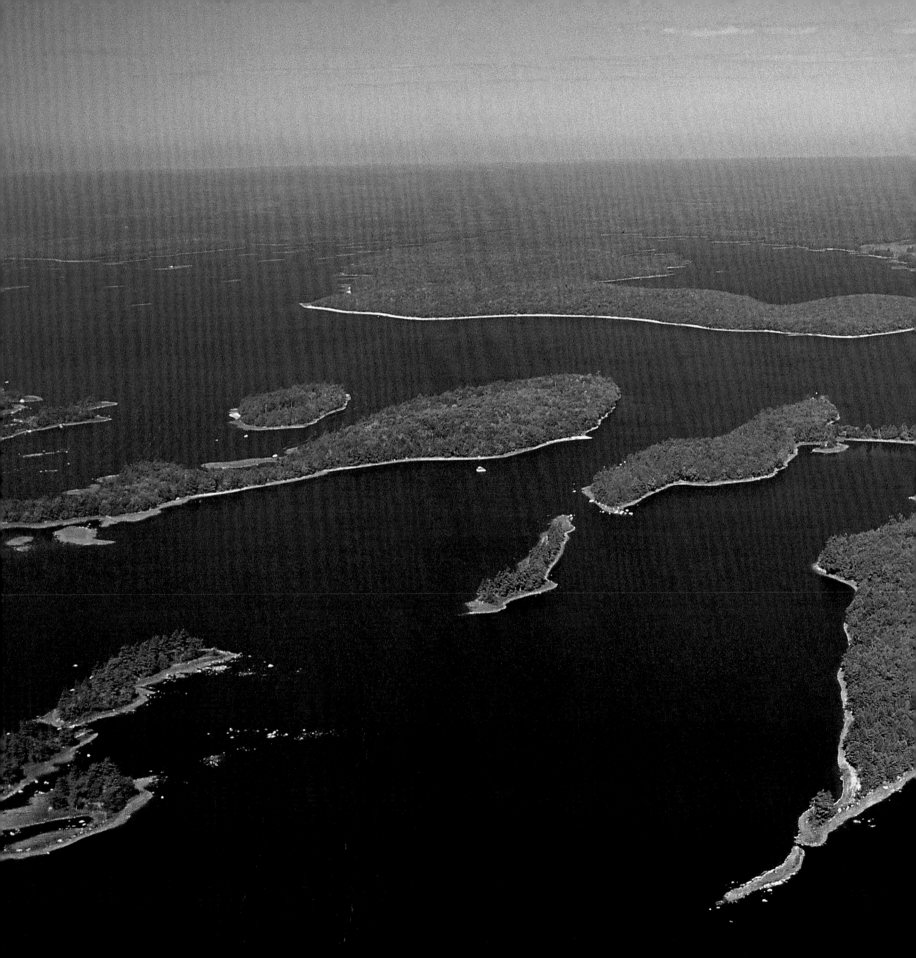

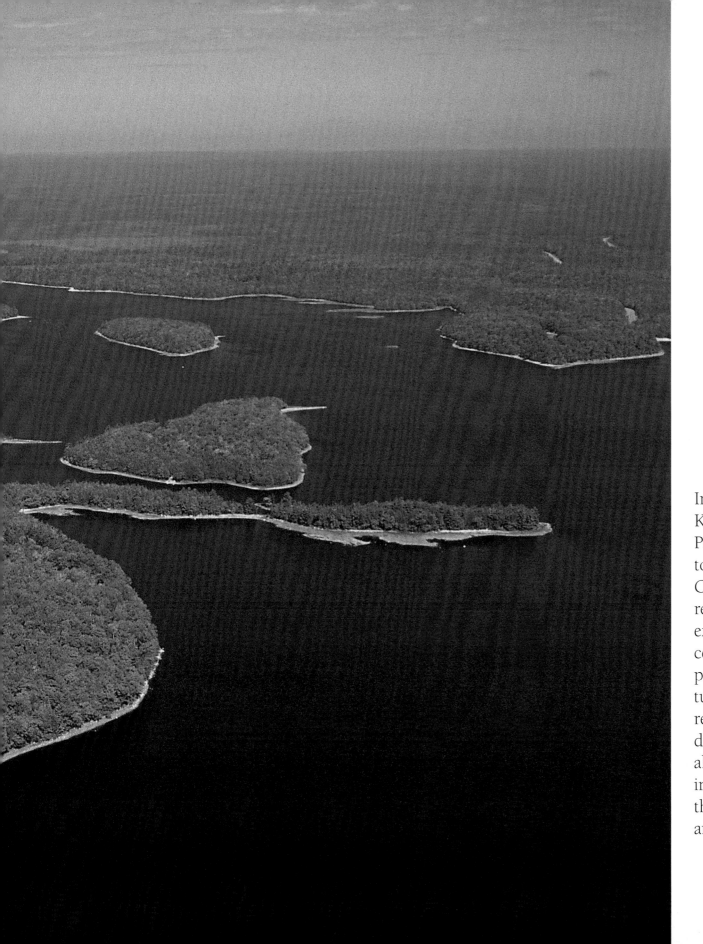

In the wetlands of Kejimkujik National Park, biologists struggle to protect one of Atlantic Canada's most important reptile habitats. For example, over 95 percent of the entire species population of Blanding's turtles lives within the refuge. Snakes, salamanders, toads, and frogs also make their home in the shallow waters, threatened by pollution and acid rain.

Kejimkujik National Park's Seaside Adjunct encompasses an additional 22 square kilometres (8.5 square miles) of the Atlantic coast. While wind and waves scour the shore each year, a few reminders of the past remain—rock foundations, fence fragments, and cattle trails from the days when the land served as summer pasture for local farmers.

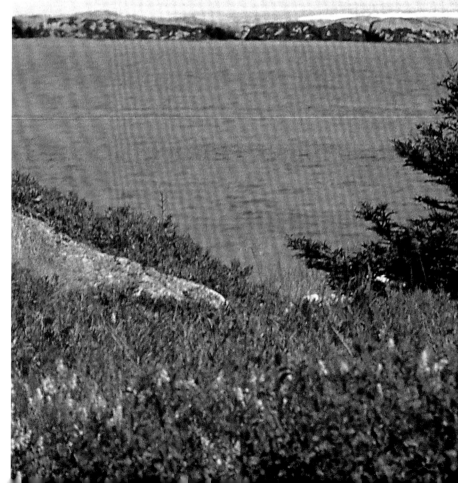

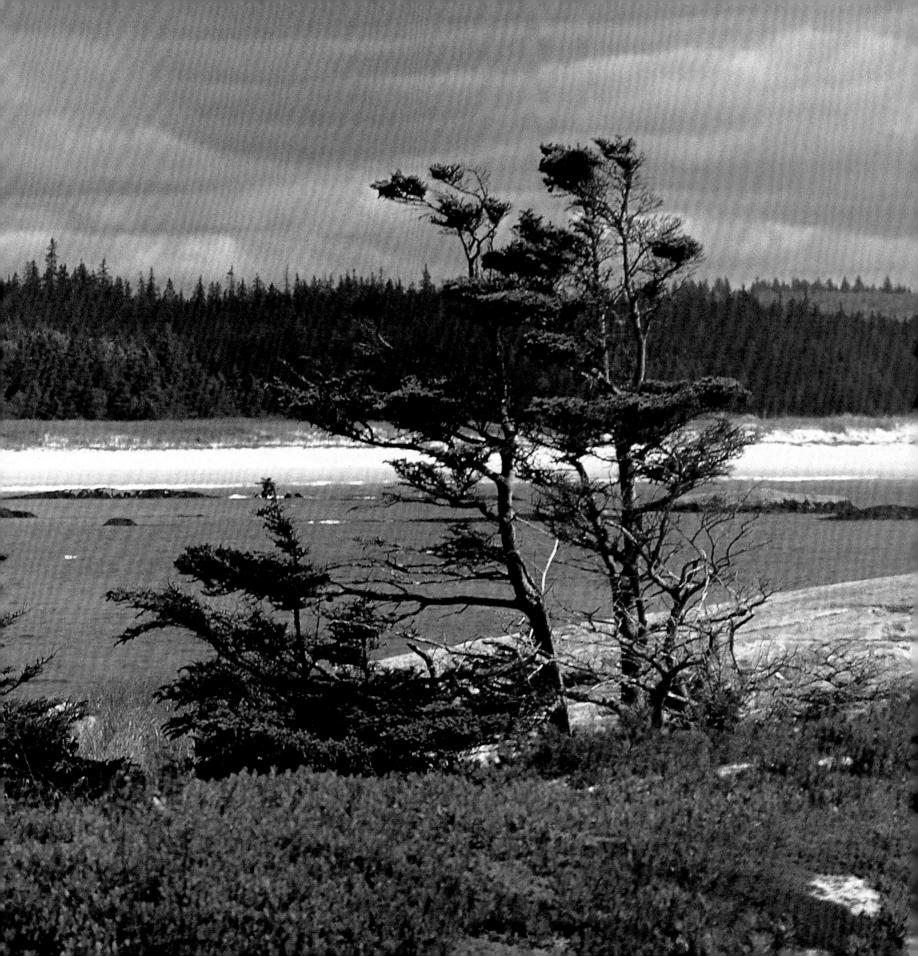

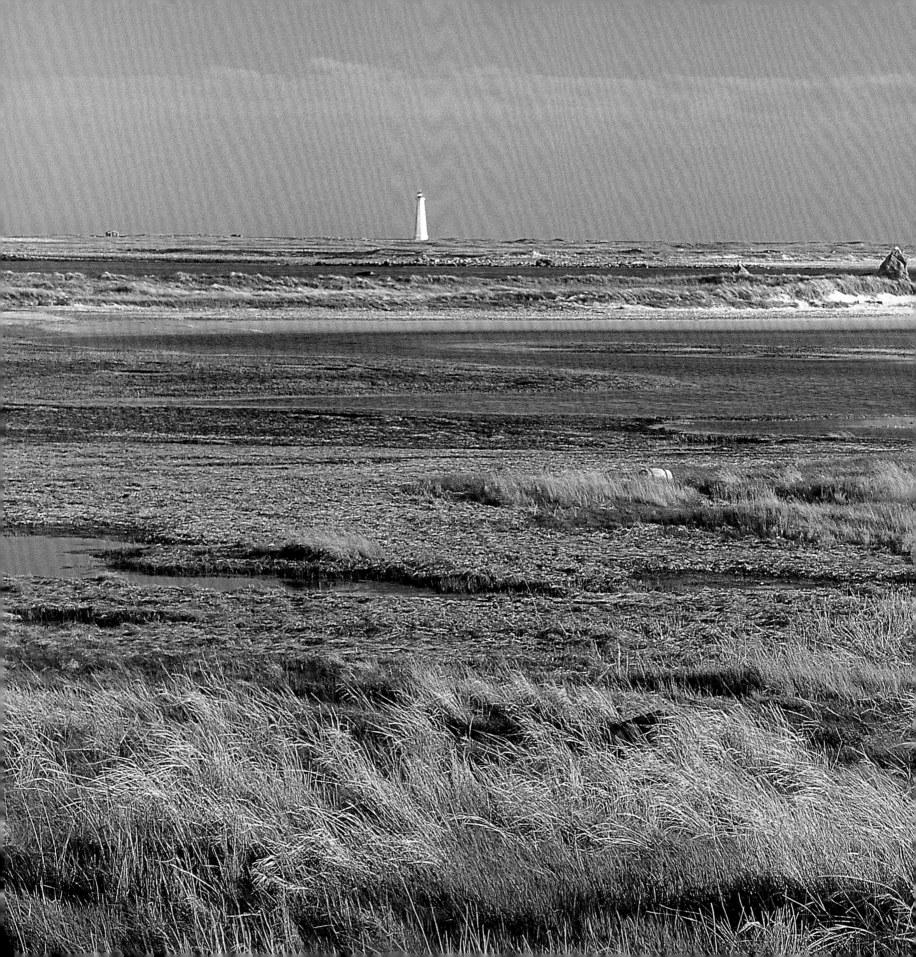

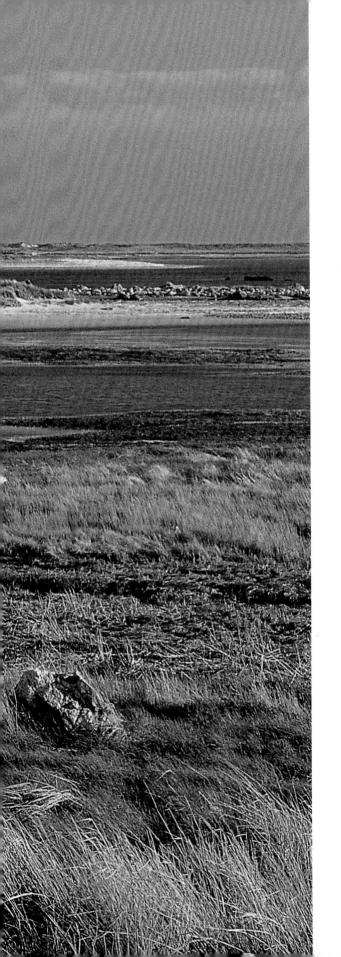

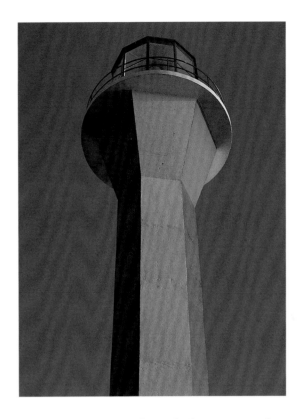

When the Coast Guard replaced the original 1840 Yarmouth Lighthouse in the 1960s, they traded the traditional octagonal wooden building for a slender concrete tower. Walking trails, a museum, and a gift shop cater to lighthouse enthusiasts.

Only 11 kilometres (7 miles) long and less than 5 kilometres (3 miles) wide, Cape Sable Island lies at the southernmost tip of Nova Scotia, linked to the mainland by a causeway. Before a lighthouse was built in the 1860s, the hidden shoals surrounding the low, sandy island caused frequent shipwrecks.

39

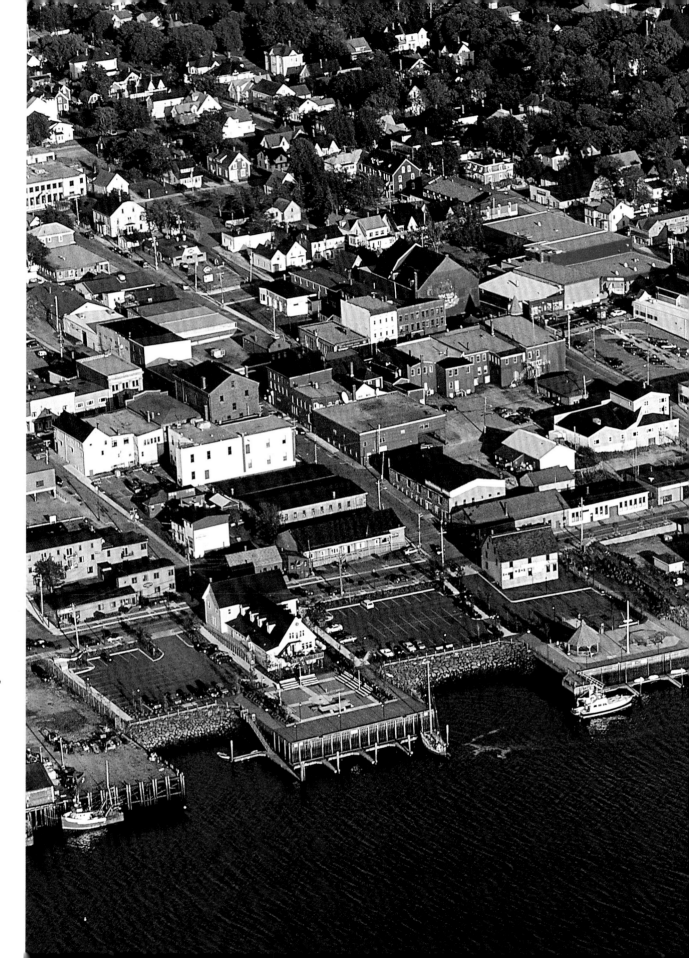

Museums, art galleries, and lighthouses entice visitors to Yarmouth, founded by British farmers and fishers in the 1700s. Sightseers explore the local beaches, join walking tours past some of the town's nineteenth-century sea captains' homes, and watch the herring fleet leave the docks just before sundown.

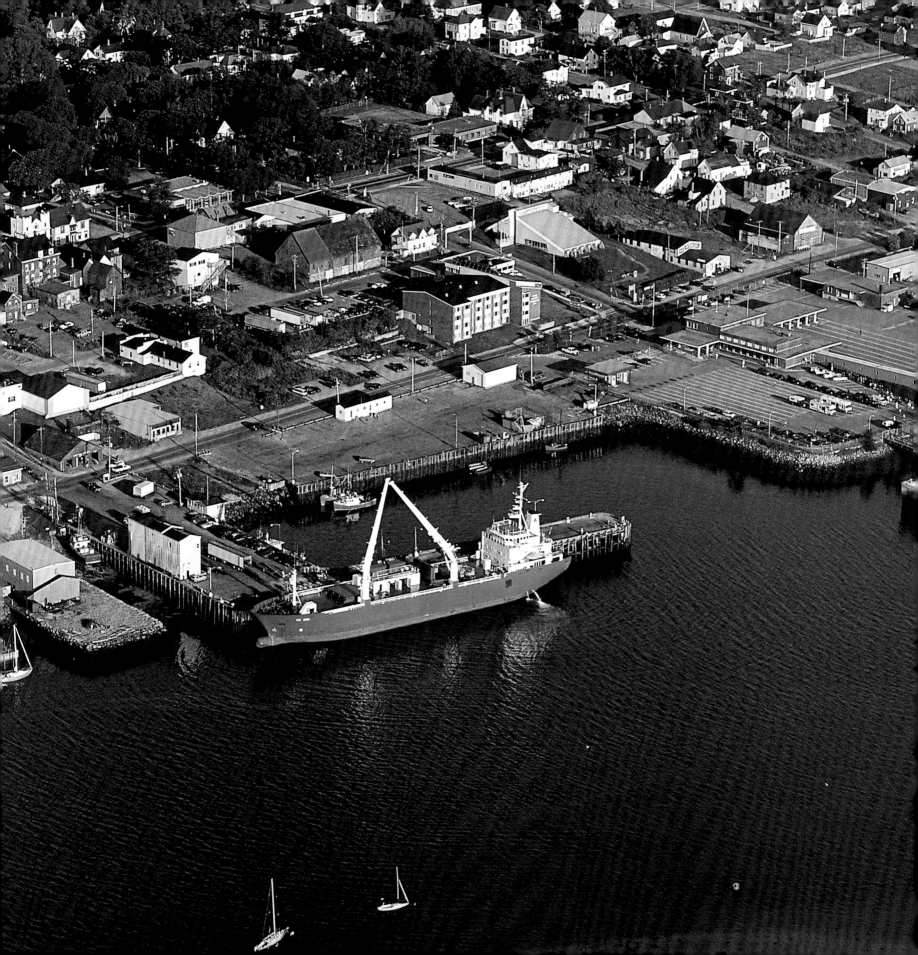

The tides in the Bay of Fundy are the largest in the world and currents churn through the Minas Channel as water from the Atlantic sweeps in and out of the bay. The cliffs of Cap D'Or—named "cape of gold" by early explorers—tower high above the waves.

FACING PAGE
In the time of the dinosaurs, Balancing Rock near Digby was one of many basalt columns forming the clifftop. While the surrounding ridge has eroded, falling slowly into the sea, Balancing Rock remains. A short hiking trail takes sightseers to a viewing platform near the intriguing formation.

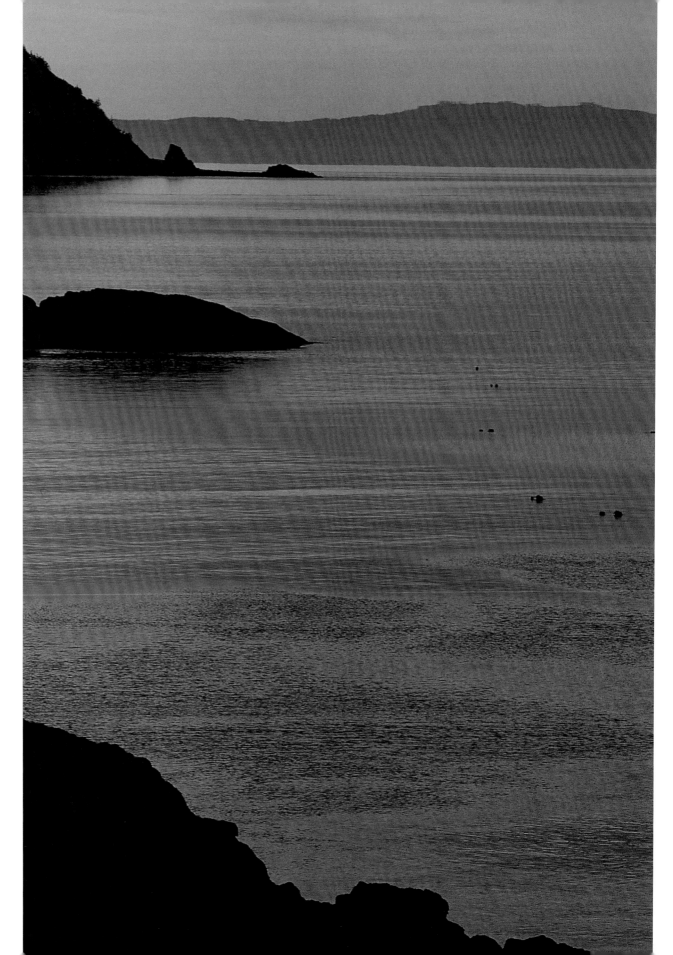

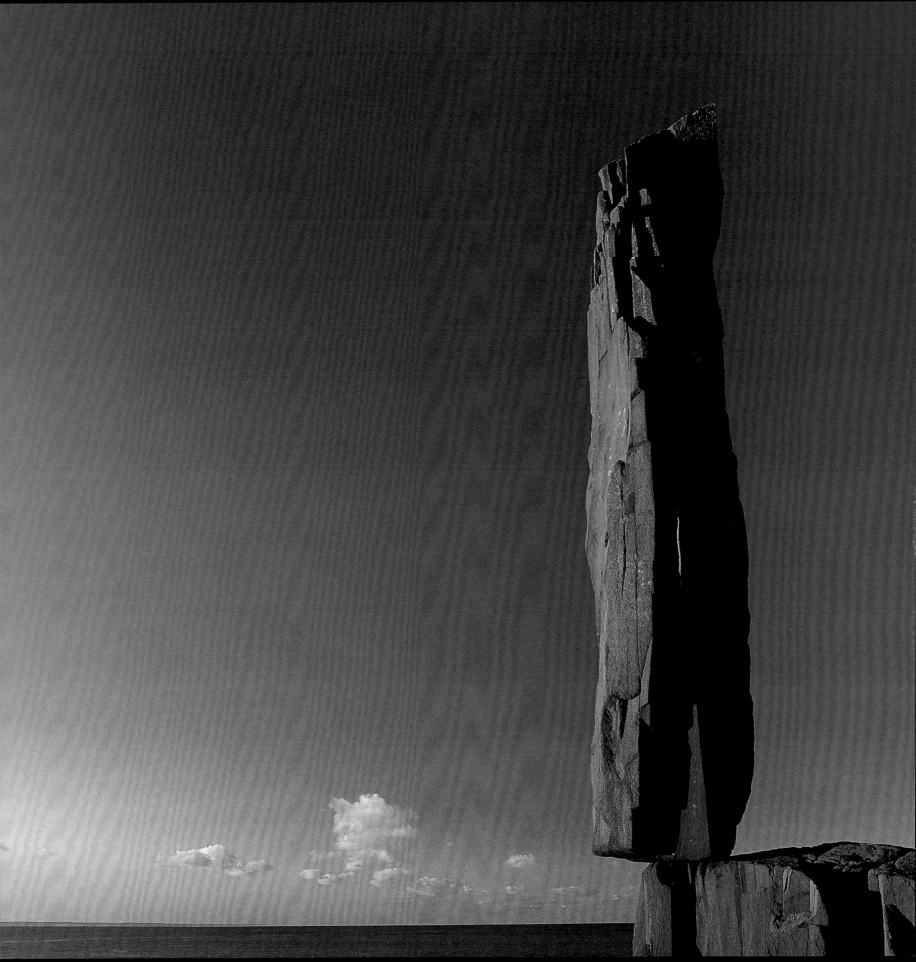

The town of Digby sprawls along the shores of the Bay of Fundy. At the water's edge, buildings perched on pilings house specialty shops and seafood eateries, while the Digby scallop fleet docks a short distance away. Fresh scallops, lobster, and fish caught in the bay are exported around the world.

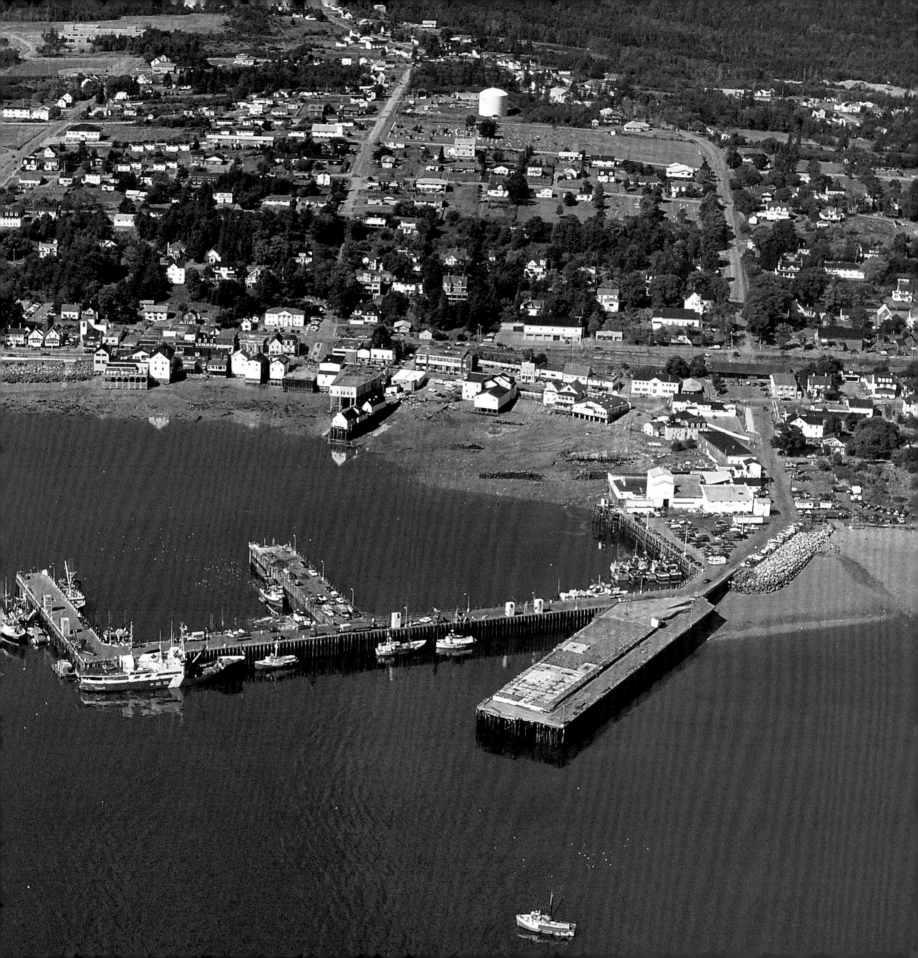

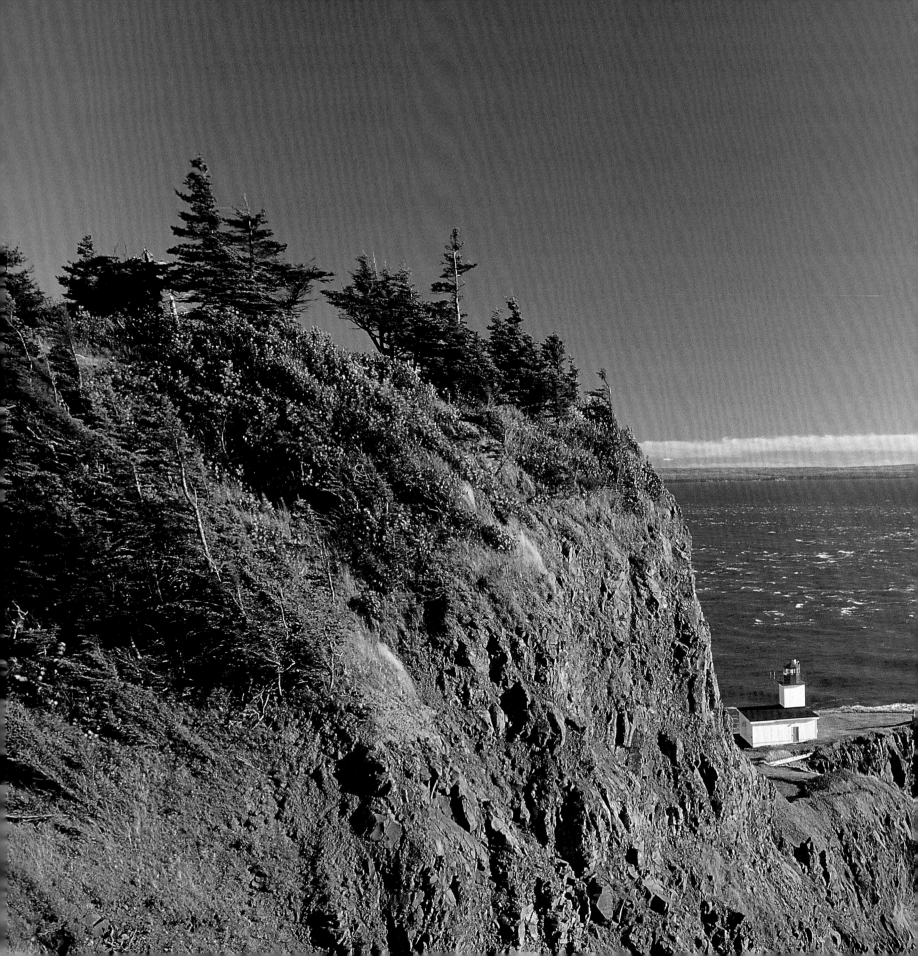

The first lighthouse built at Cap D'Or in 1922 was designed to warn mariners of the strong tidal currents. It was replaced by a concrete light in 1965. The cliffs above the beacon were once the home of rare peregrine falcons, and biologists are now attempting to reintroduce the raptor to the area.

47

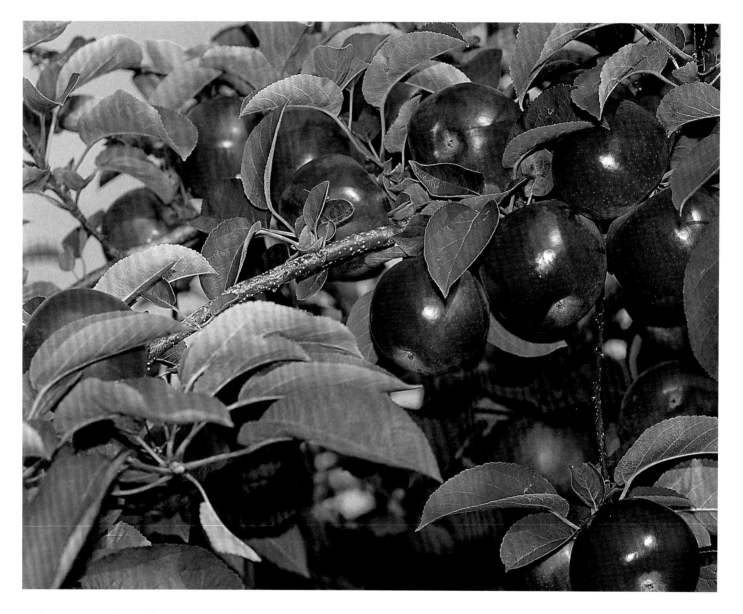

When French settlers—now known as Acadians—arrived in the Annapolis Valley in the mid-1600s, they brought the expertise needed to dyke the land and protect it from the nearby salt water. They also brought crops from the Old World, including many of the apple varieties that continue to flourish in the region today.

When competition and trade tariffs threatened the family farms of Nova Scotia's Annapolis Valley, many landowners diversified their crops. Along with the valley's famous apples, the region produces cranberries, peaches, cherries, apricots, flowers, Christmas trees, and organic produce.

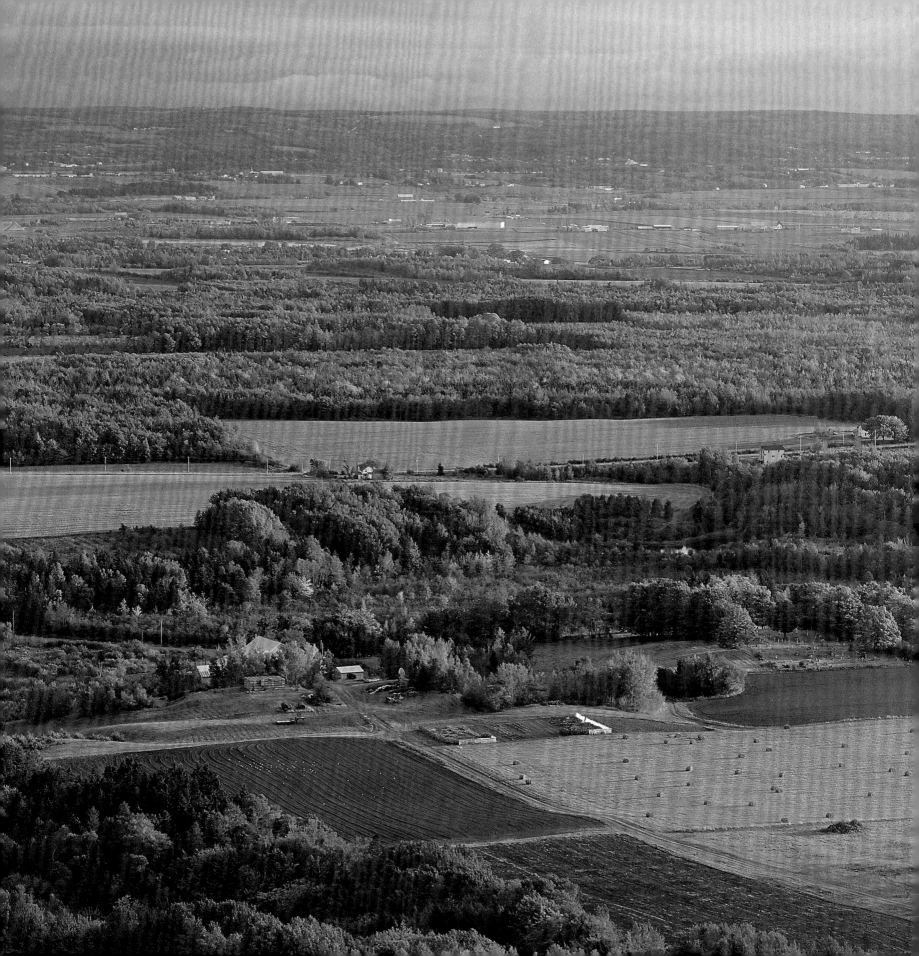

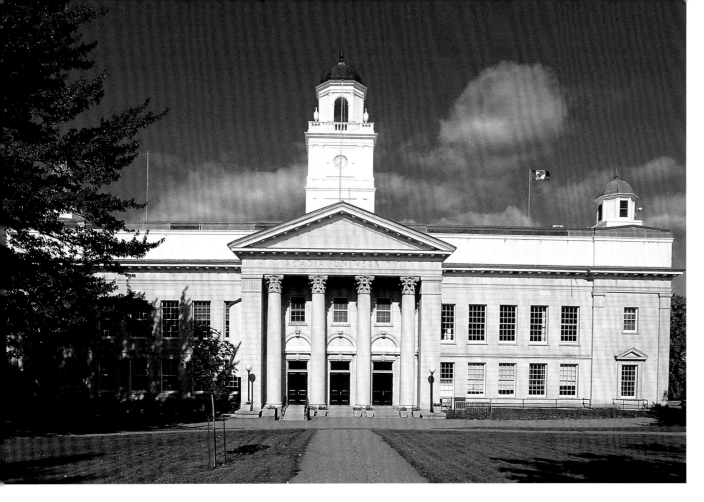

Serving more than 3,600 students, Acadia University in Wolfville has won numerous awards for innovation, technology, and the quality of its undergraduate programs. The school's alumni include former Prime Minister Sir Charles Tupper, Nobel prize winner Charles Huggins, author and photographer Freeman Patterson, and astronomer and comet-hunter David Levy.

Grand Pré National Historic Site commemorates the successes and tragedies of the Acadian people. After peacefully farming the land for almost a century, they were caught in a battle between the French and the British, who had taken control of Nova Scotia. In 1755, the Acadians were expelled from Nova Scotia, forced to disperse and remake their lives in the colonies to the south.

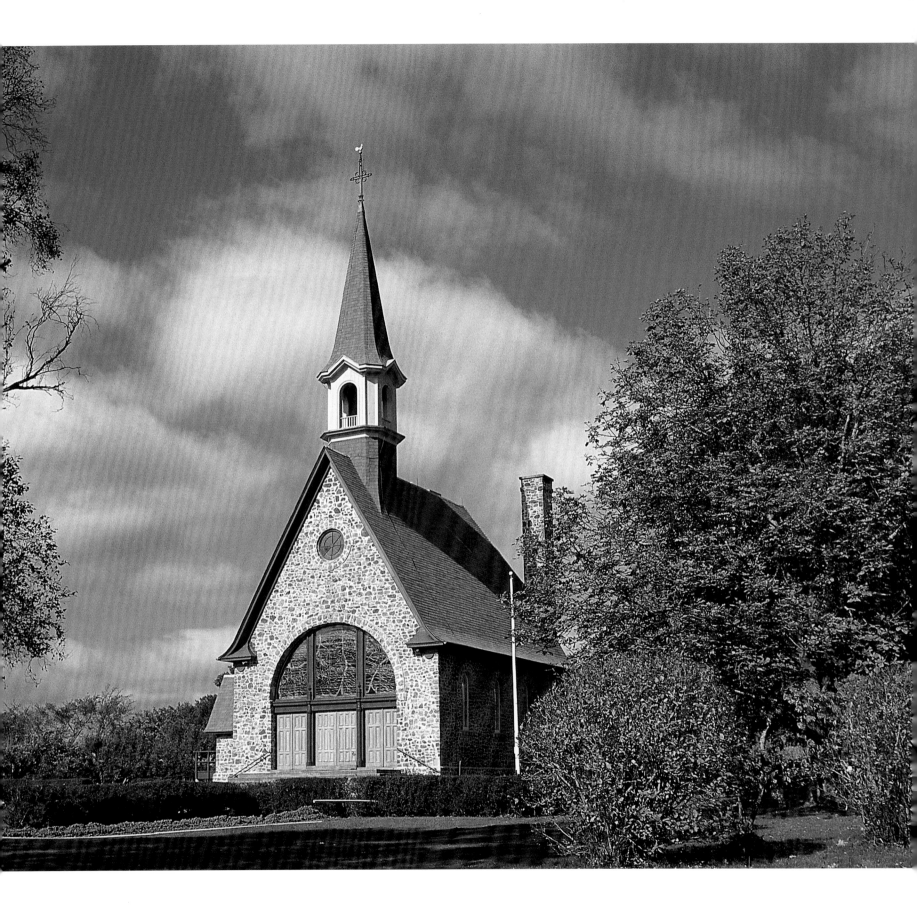

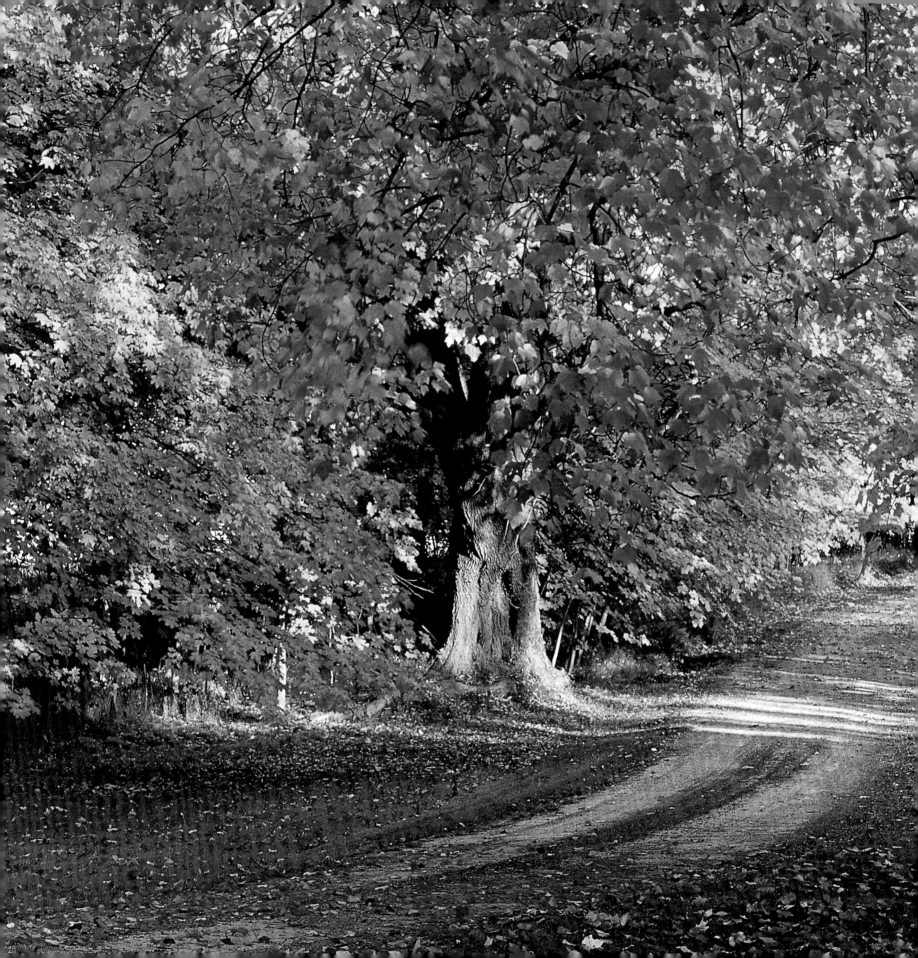

Port Williams is a picturesque agricultural village nestled between the towns of Kentville and Wolfville. The area offers sightseers the chance to see Nova Scotia's vivid fall colours, enjoy the fresh local produce, and view the astounding tides of the Bay of Fundy's Minas Basin.

53

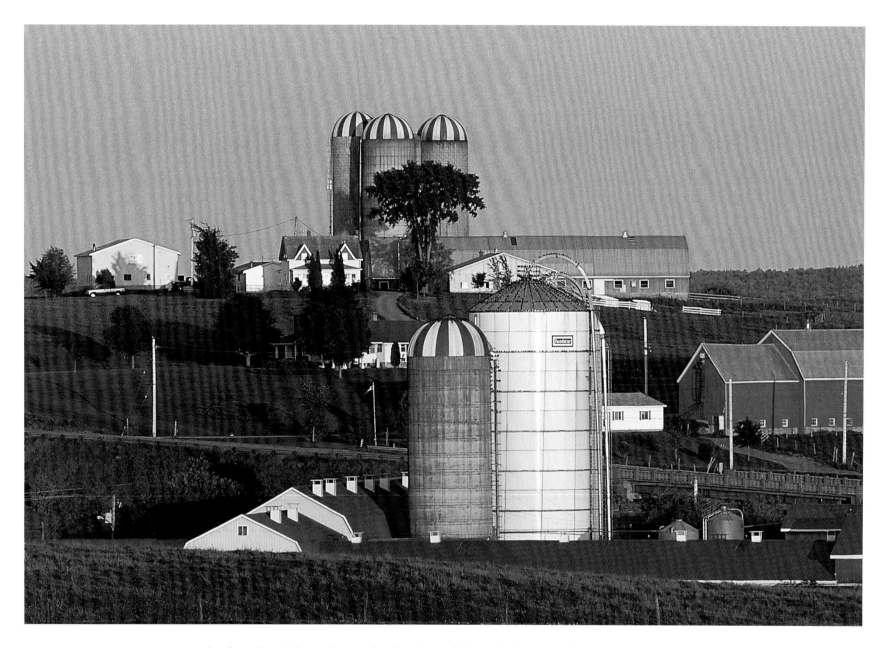

Fertile farmland lies along the banks of the Shubenacadie River, named by the Mi'kmaq people for the edible ground nuts that grew along the banks. Nearby, rafting companies offer adventurous travellers a trip through a tidal bore, when the tides of the Bay of Fundy reverse the river's flow. The Shubenacadie Provincial Wildlife Park protects bald eagles, owls, bobcats, and coyotes.

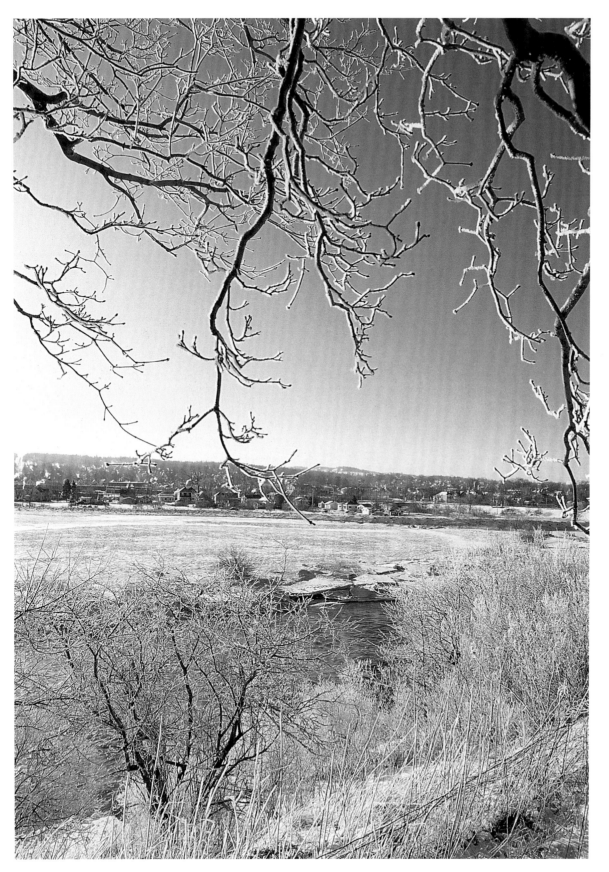

Snowy branches frame a view of Truro, at the northern tip of the Bay of Fundy. The Mi'kmaq people called the land Wagobqitk, or "the end of the waters." British and Loyalist settlers renamed it Trucrow, then Truro.

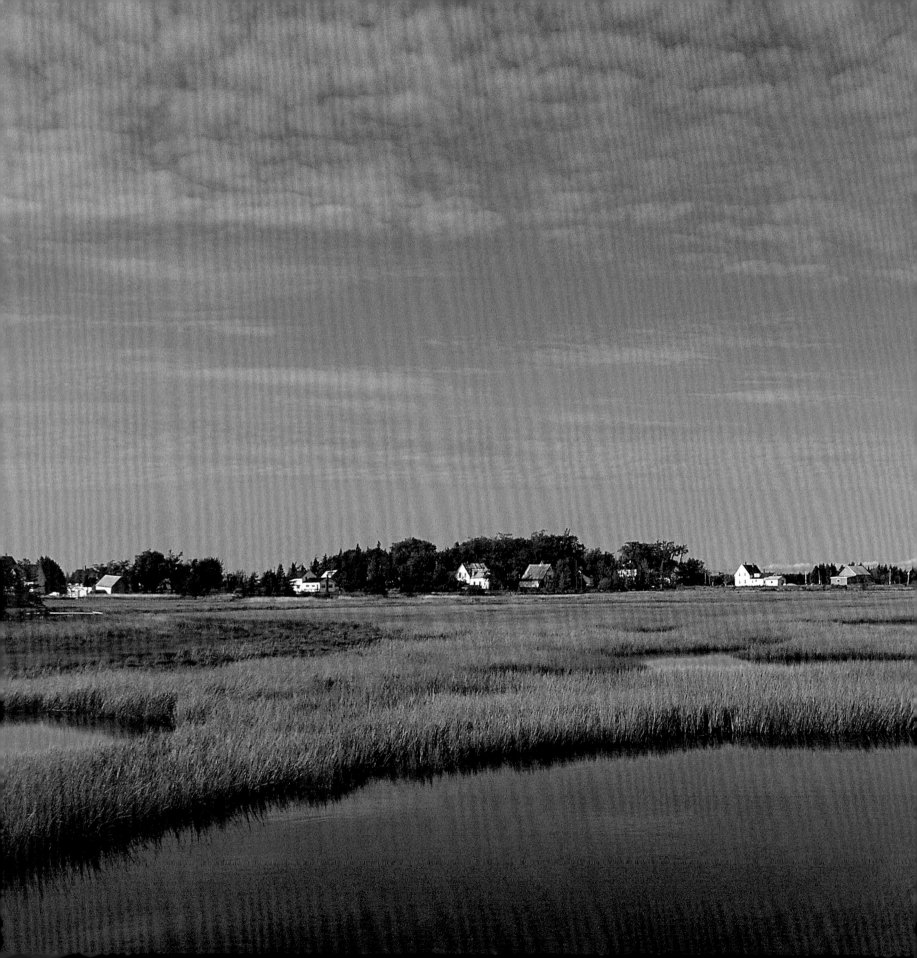

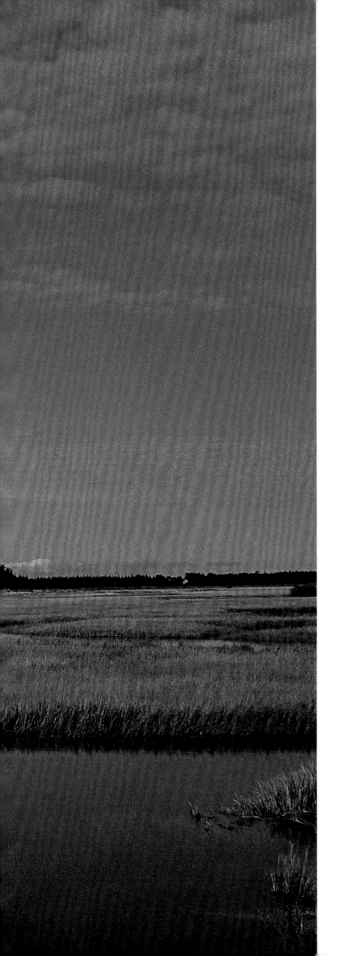

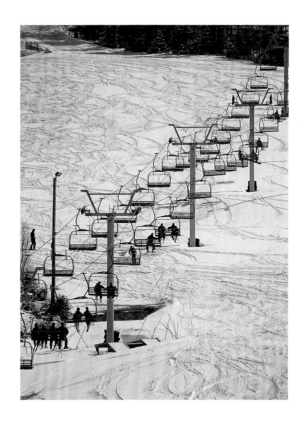

The first skiers explored Wentworth Valley in the 1930s. Today the popular winter resort boasts 250 vertical metres (815 feet) with 20 alpine trails, a tubing area, and the largest snowboarding half-pipe in Atlantic Canada, where snowboarders test their skills and practise their tricks on steep walls of snow.

One of the largest wetlands in the world, Tantramar Marsh is home to mammals, songbirds, and waterfowl. Centuries ago, this land was dyked and drained by Acadian and British settlers. Today, conservationists are working to return parts of the 49,000-hectare (123,000-acre) plain to their natural states.

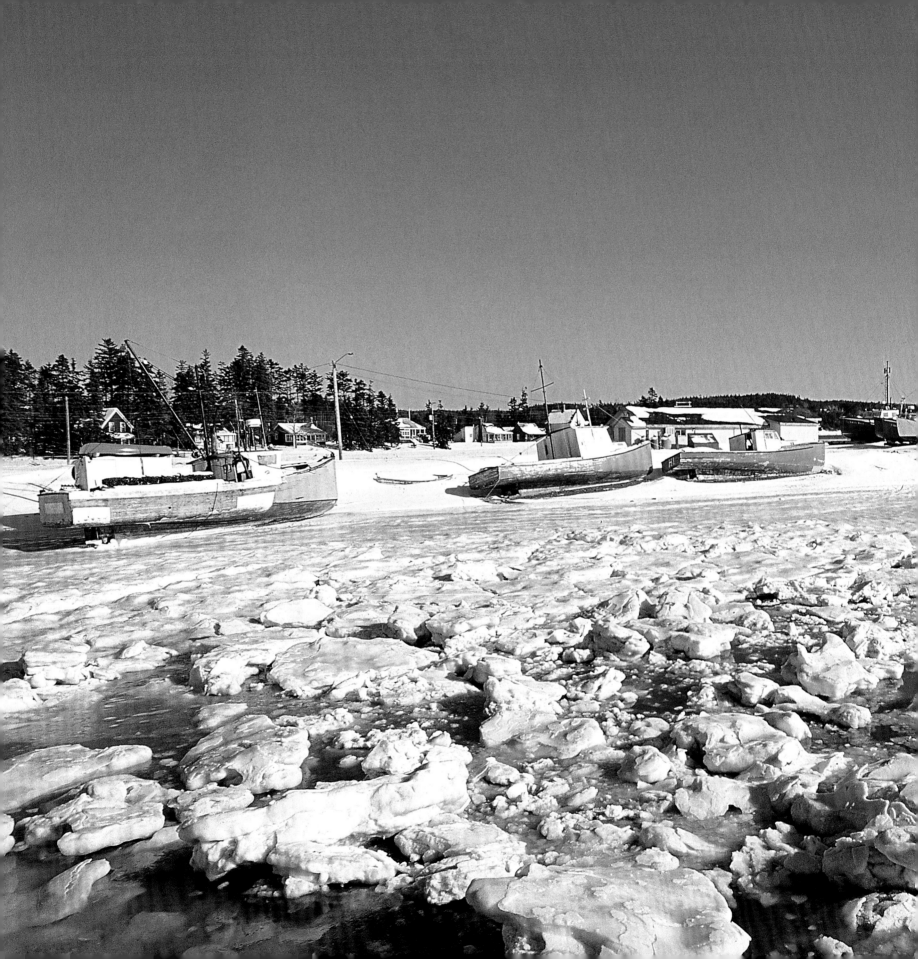

The Anne Murray Centre in Springhill opened in 1989 to celebrate the achievements of the town's most famous daughter, singer Anne Murray. Exhibits showcase star memorabilia, awards, and career highlights. The centre's audio collections allow visitors to hear Murray's talent for themselves.

As the snow melts each spring, rockhounds gather in Parrsboro to search for the agate and amethyst stones found in the cliffs and on the beaches surrounding the Minas Basin. Fossil beds in the area include more than 100,000 specimens, and in 1985 scientists discovered footprints the size of pennies—the smallest dinosaur tracks ever found.

The Cumberland County Museum explores the history of the region, from the cultures of the early native inhabitants to the settlement, farming, and industry of the nineteenth and early twentieth centuries. The museum is housed in the 1838 Amherst residence of Robert Barry Dickey, one of the Fathers of Confederation who attended the Charlottetown and Quebec conferences.

Built in 1871 with attached keeper's quarters, the Pugwash Light has since been replaced with an automated beacon. Nova Scotia's shores are home to more than 150 lighthouses, more than in any other Canadian province.

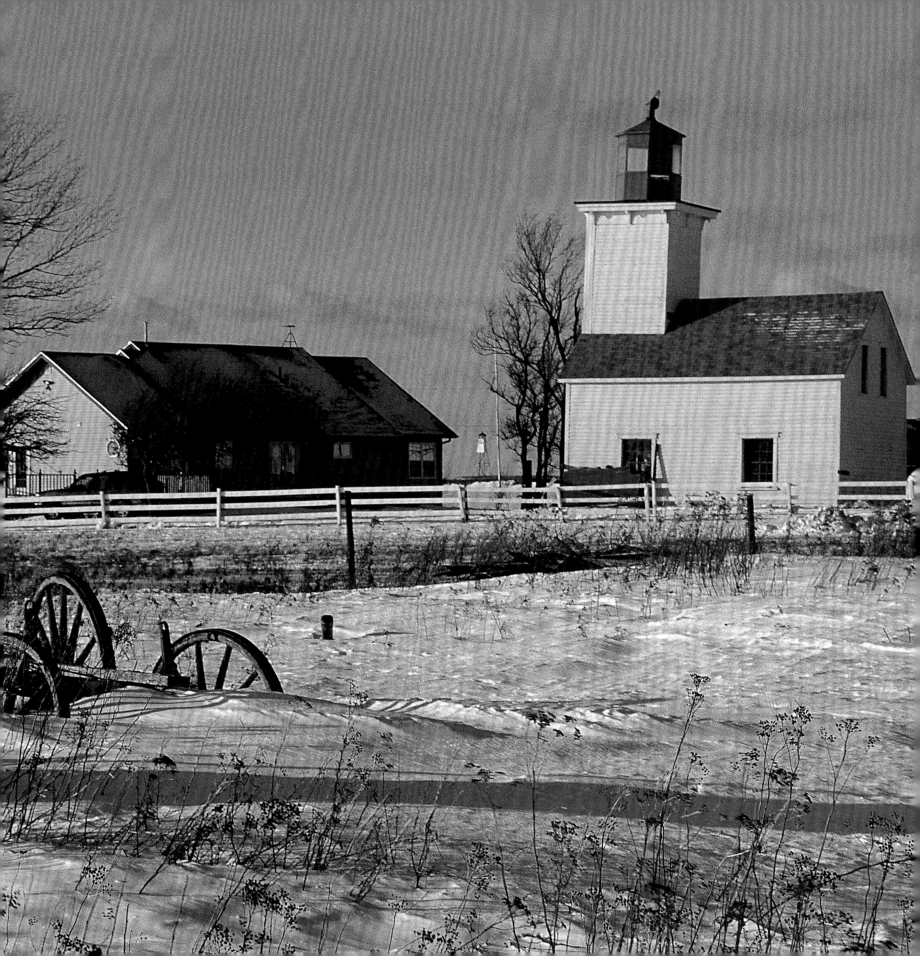

In 1773, Scottish settlers arrived in Pictou, christening the area Nova Scotia, or "New Scotland." Local residents celebrate New Scotland Days each fall, with festivities that include a re-enactment of the immigrants' arrival, a harbour boat light-up, a golf tournament, and a model boat show.

FACING PAGE
Founded in 1853 and moved to Antigonish in 1855, St. Francis Xavier University became the first co-ed Catholic institution to grant degrees to women in the 1890s. The school has continued its tradition of openness and toler- ance, and about 4,000 students are now enrolled. One of the school's best- known symbols is the X-inscribed ring worn by 95 percent of alumni.

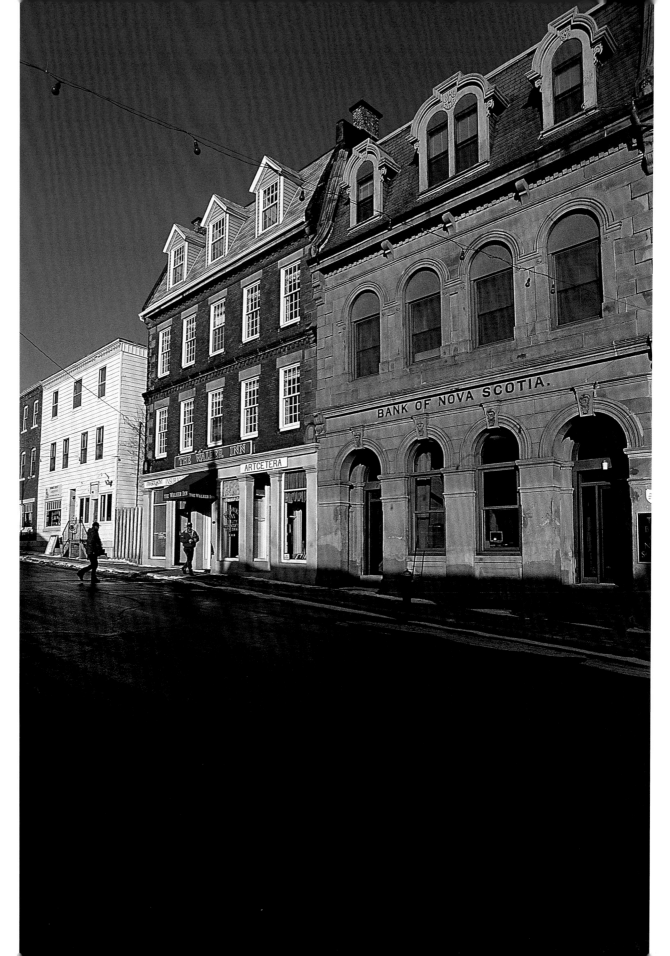

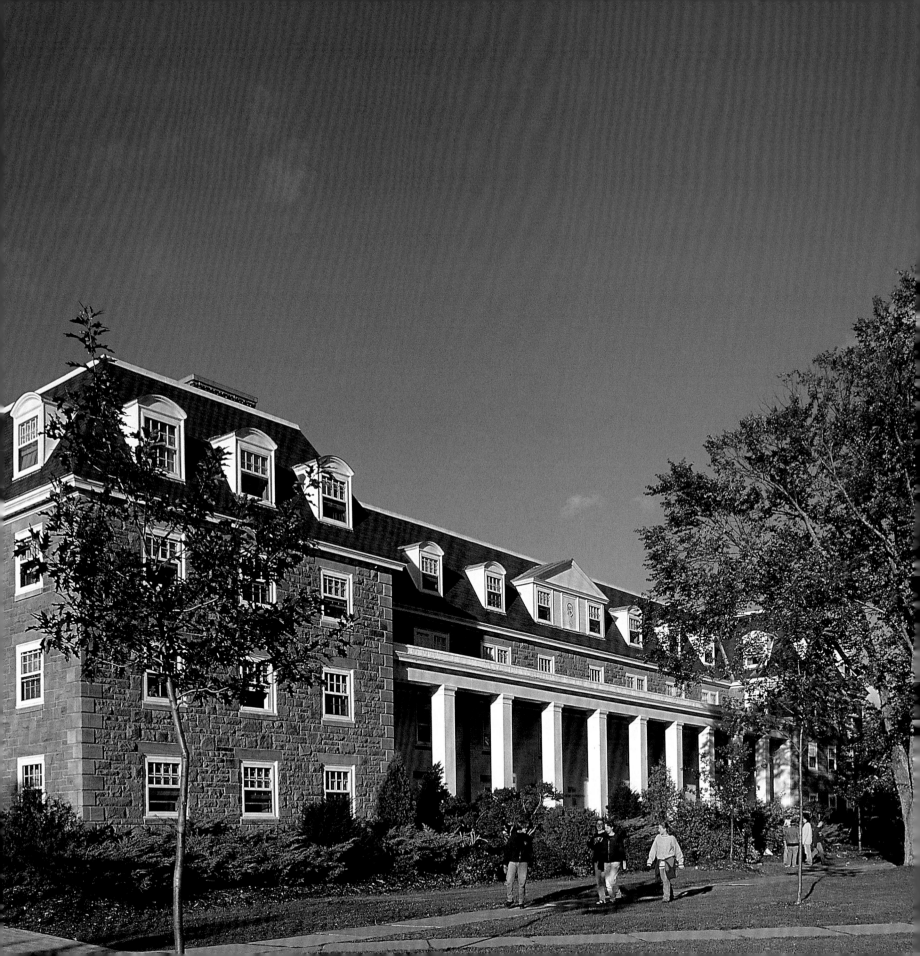

The Antigonish region is known as the Highland Heart of Nova Scotia. Each summer, the Highland Games celebrate the area's Scottish-influenced traditions, while the Gathering of the Arts reveals the lively arts community now active here.

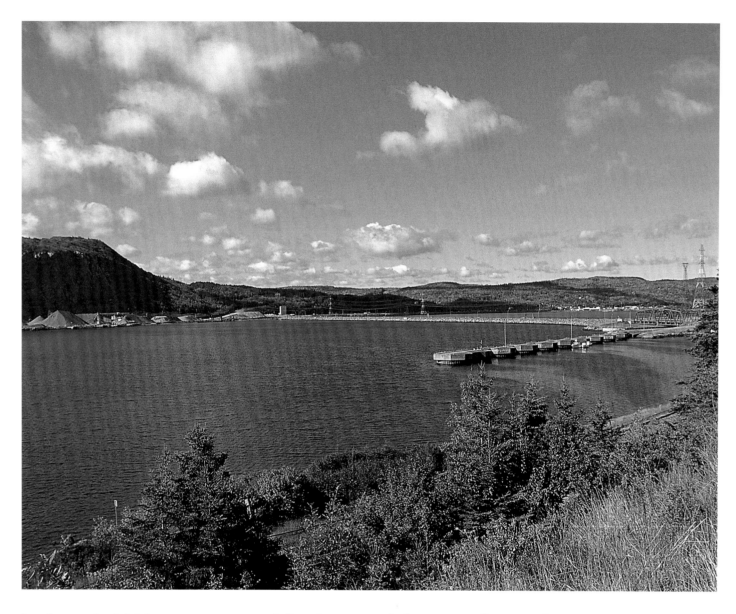

In the early 1900s, passengers and freight crossed the Strait of Canso between
mainland Nova Scotia and Cape Breton Island on the SS *Mulgrave*. In the 1950s,
about 10,254,000 tonnes (10,092,000 tons) of rock were poured into the strait
to create the Canso Causeway, permanently linking the island.

When Scottish settlers arrived on Cape Breton Island they found high, foggy
mountains bordered by a wild coast—geography that reminded them of home.
Centuries later, the landscape of Cape Breton Highlands National Park remains
much as it was when the settlers first explored the island.

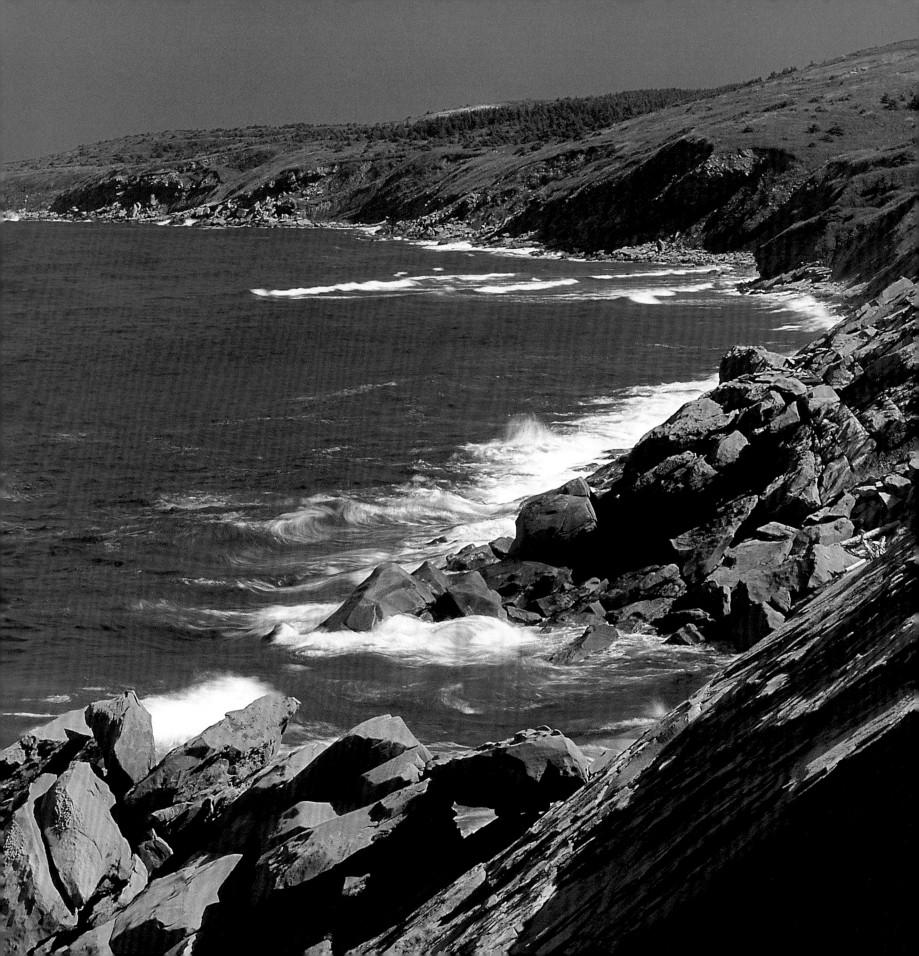

Whale Cove is one of the secluded beaches near Margaree Harbour, at the junction of the Cabot Trail and its less famous cousin to the south, the Ceilidh Trail. *Ceilidh* is a Gaelic word meaning "party," as visitors lucky enough to encounter Cape Breton fiddle music, traditional stepdancing, or one of the region's seasonal festivals soon discover.

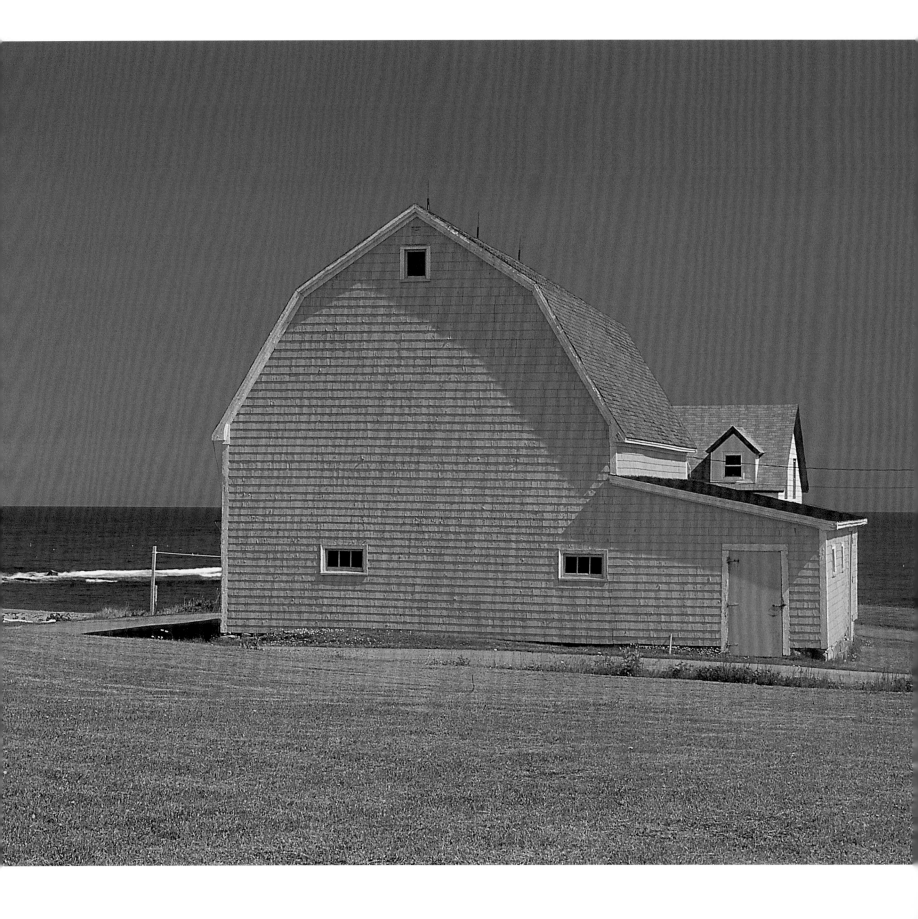

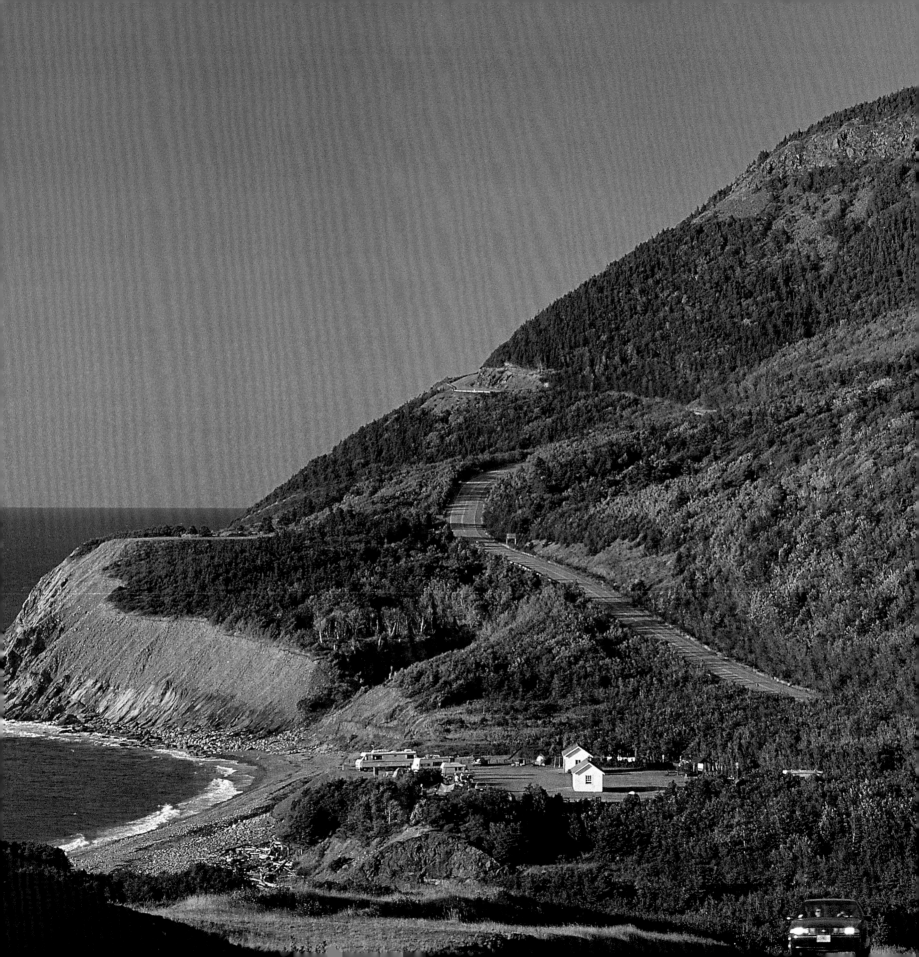

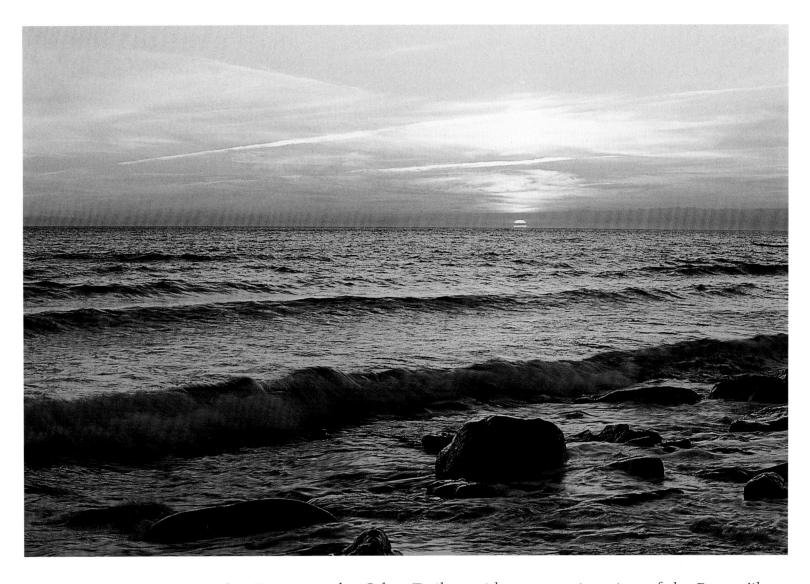

Cap Rouge on the Cabot Trail provides a sweeping view of the Presqu'ile Peninsula in Cape Breton Highlands National Park. This stretch of the highway is popular with cyclists, and those who begin their journey in Cheticamp remember the view well—it follows the first major climb of the trip.

A ribbon of pavement through the wilderness of 950-square-kilometre (366-square-mile) Cape Breton Highlands National Park, Cabot Trail leads up to some of the island's highest points, then down to the rugged coast. Though the segment from Cheticamp to Ingonish takes only two hours to drive, most visitors take the day to enjoy the magnificent views.

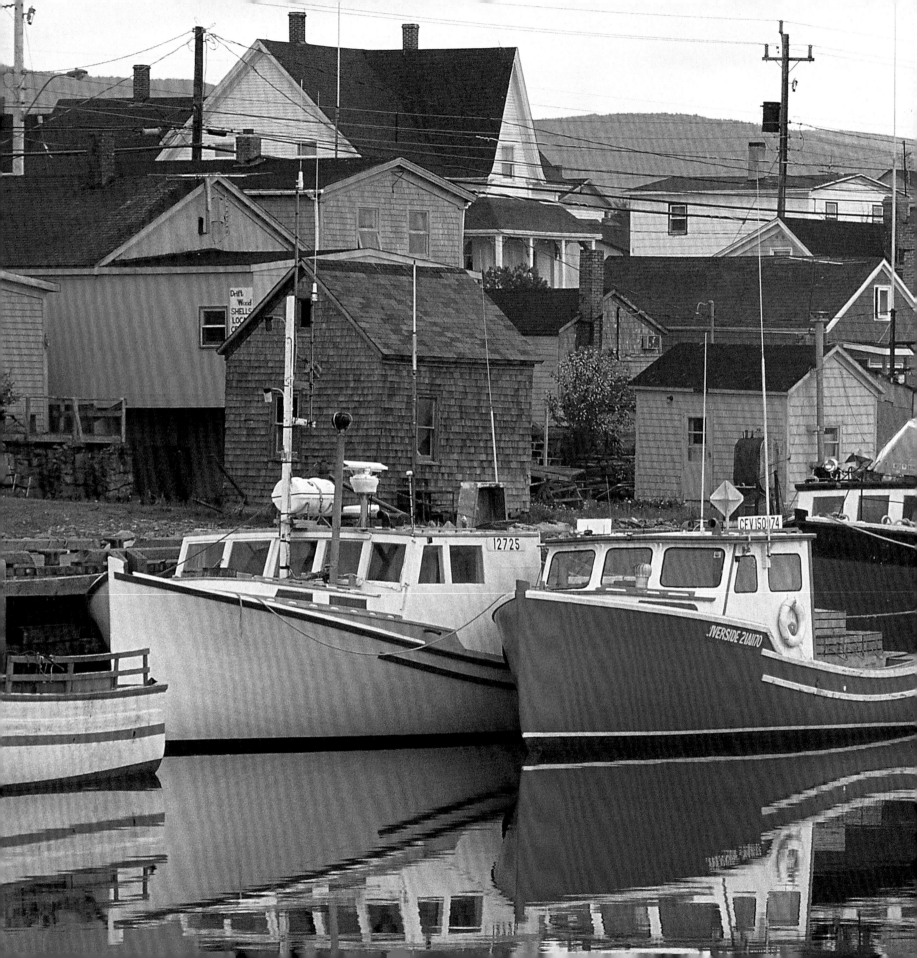

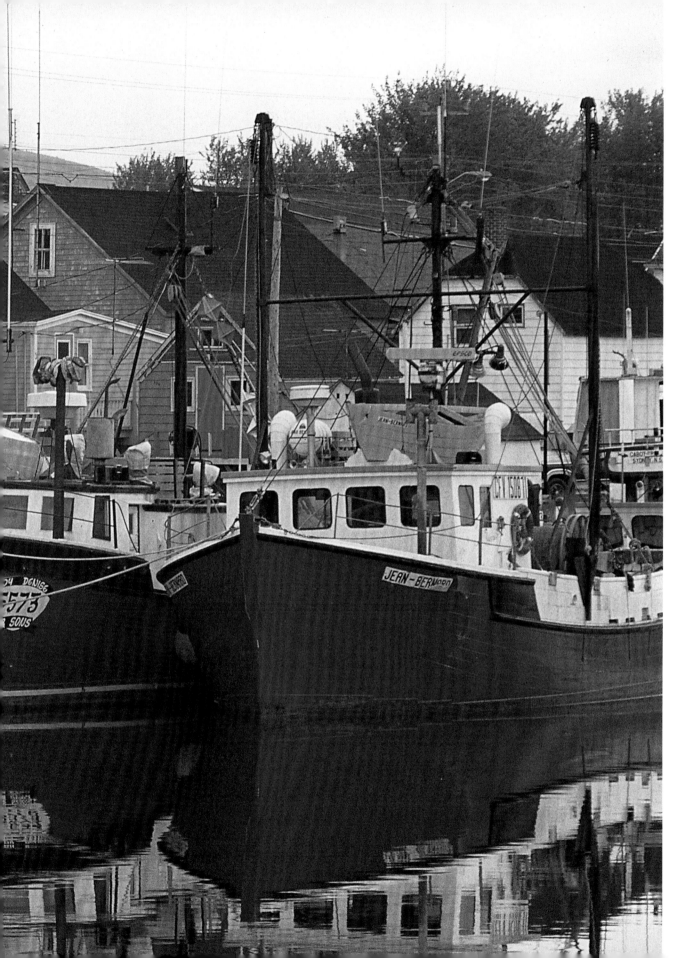

Skirted by the Gulf of
St. Lawrence to the west
and the Cape Breton
Highlands to the east,
the Acadian settlement
of Cheticamp is so
remote that residents
still speak with unique
inflections. The town's
folklore, traditional
a capella songs, and
local cuisine draw
interested visitors
each summer.

73

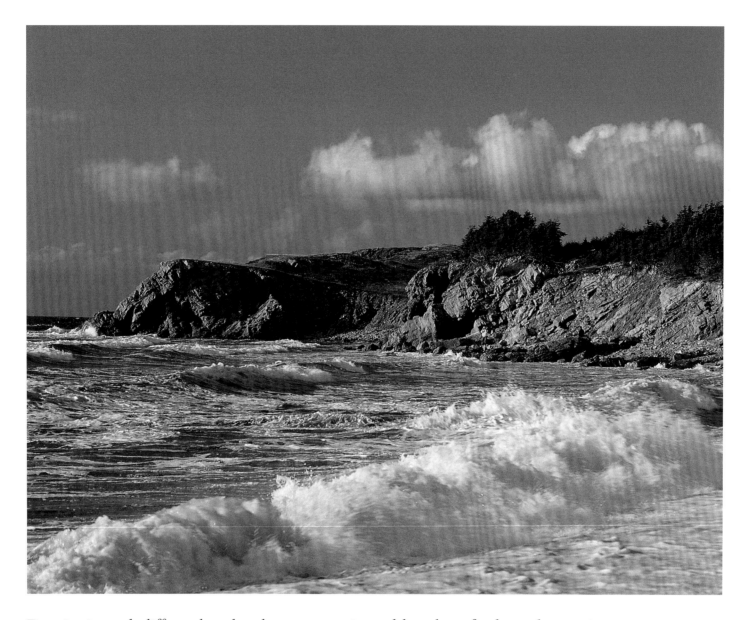

Despite jagged cliffs and rocky shores, experienced kayakers find much to enjoy
along the coast of Cape Breton Island—the glow of sunset from an isolated beach,
the sight of whales breaching nearby, and otherwise inaccessible coastal views.

Many of Cape Breton Island's communities were inaccessible by road until the early
1900s. Residents lived isolated lives, receiving supplies by boat and their mail by
dog team or horse and rider. It was the potential for tourism that prompted the
provincial government to link the outposts in the late 1920s, which led to the
creation of the Cabot Trail.

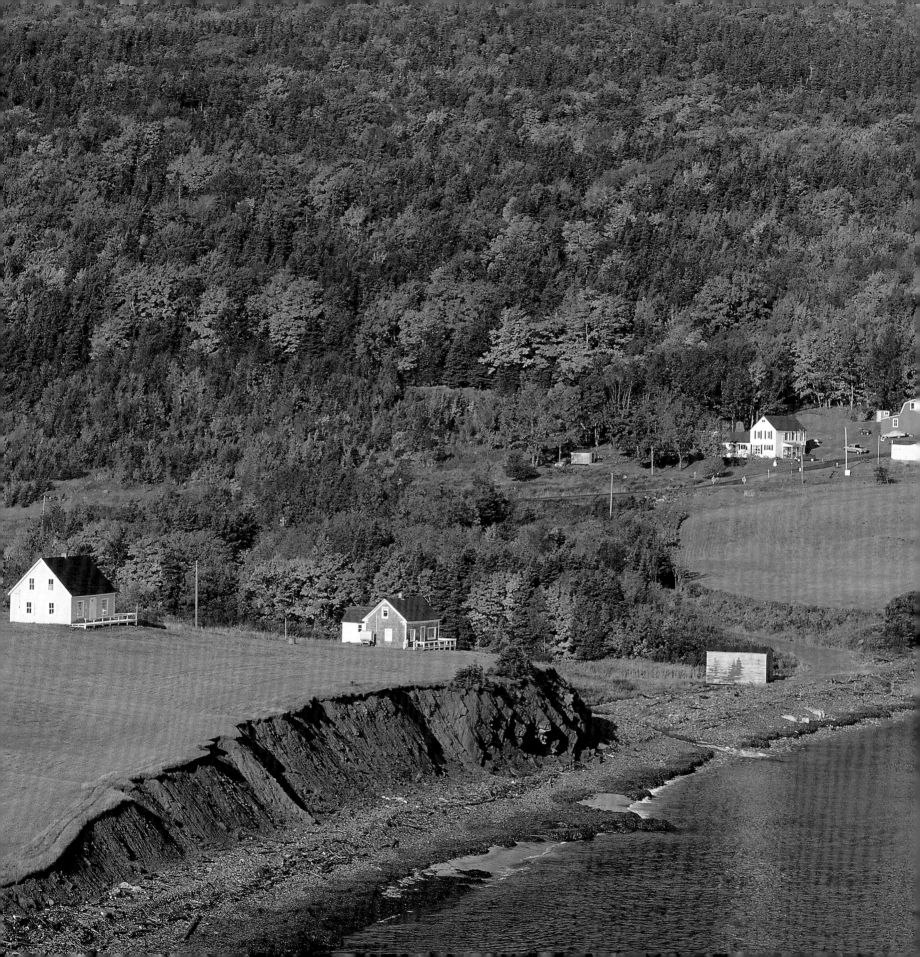

A popular stop on the route between Cheticamp and Ingonish, Beulach Ban Falls also marks the beginning of a 10-kilometre (6-mile) loop trail within Cape Breton Highlands National Park. The park offers 25 other diverse routes, as well as six campgrounds, golf courses, and cross-country ski trails.

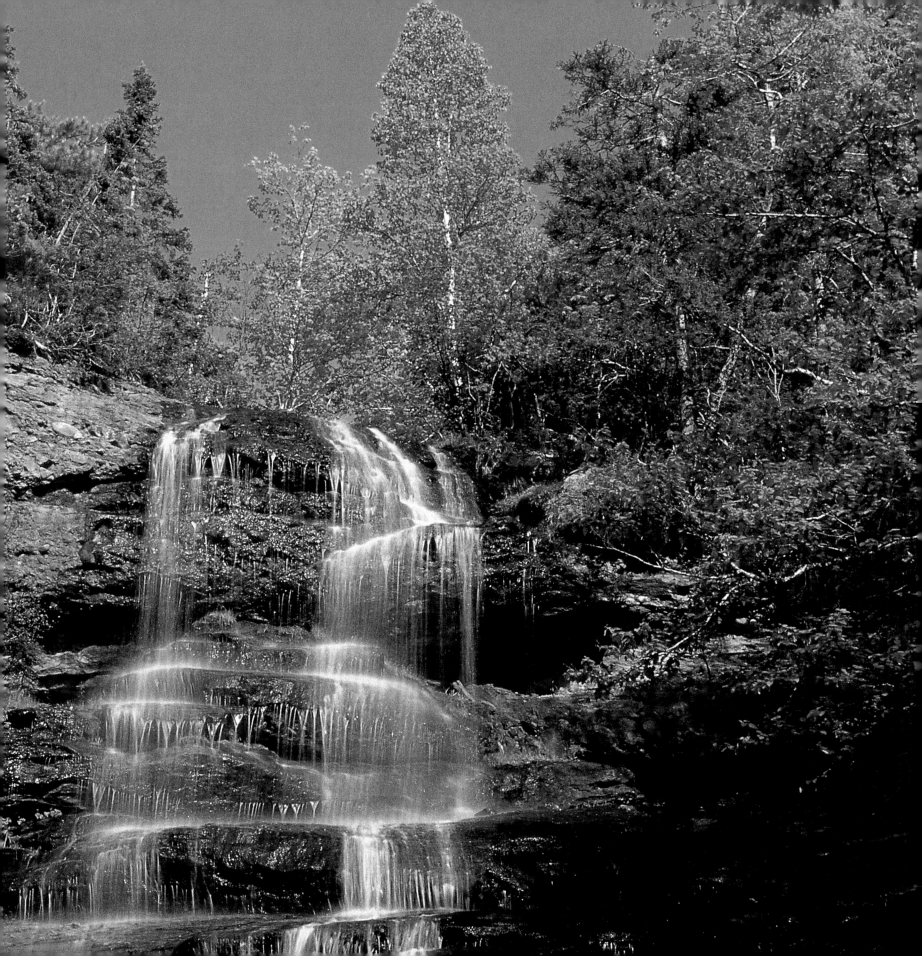

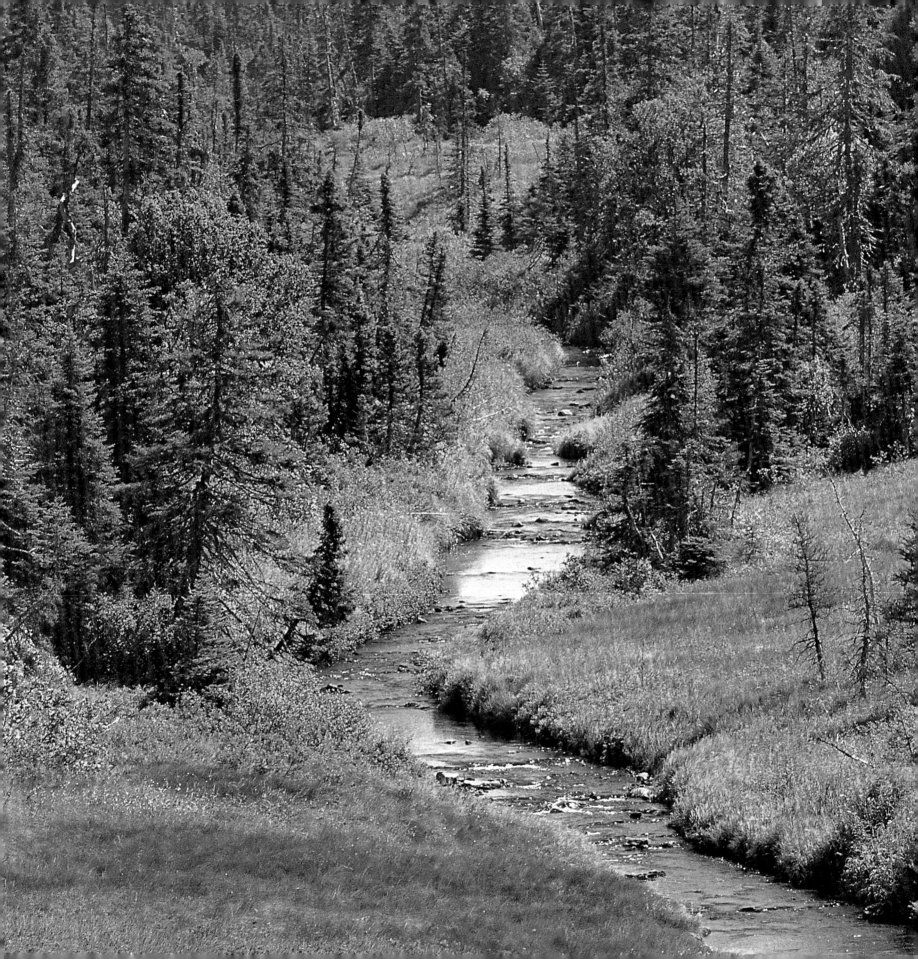

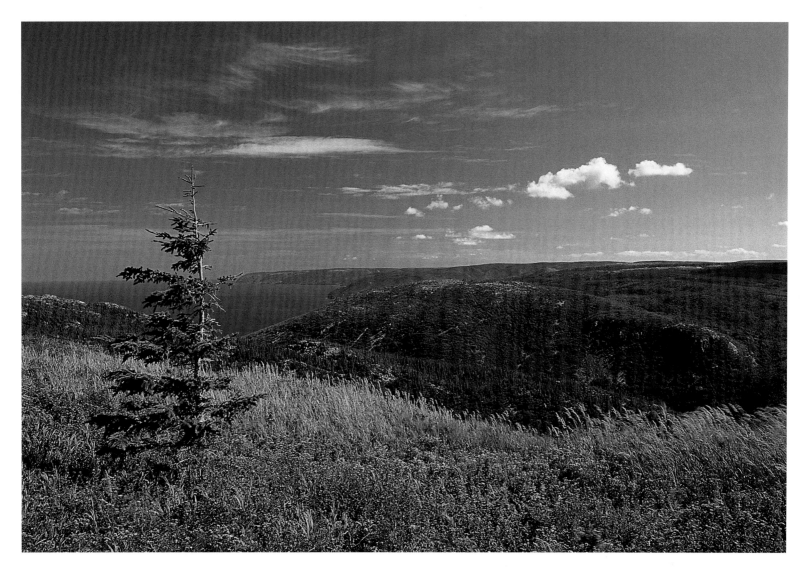

Carved of schist, gneiss, and granite, the highlands of Cape Breton Island rise to 532 metres (1,745 feet) above sea level, skirted by bluffs and cliffs more than 300 metres (984 feet) high. The elevation and wind cut the growing season short, and the plateaus are blanketed in species usually found north of the continental treeline.

Once a tiny fishing outpost, Fishing Cove River on the Gulf of St. Lawrence now serves as a backcountry campsite in Cape Breton Highlands National Park. Those who challenge the 16-kilometre (10-mile) trail to the cove can find freshwater and saltwater swimming spots or angle for trout.

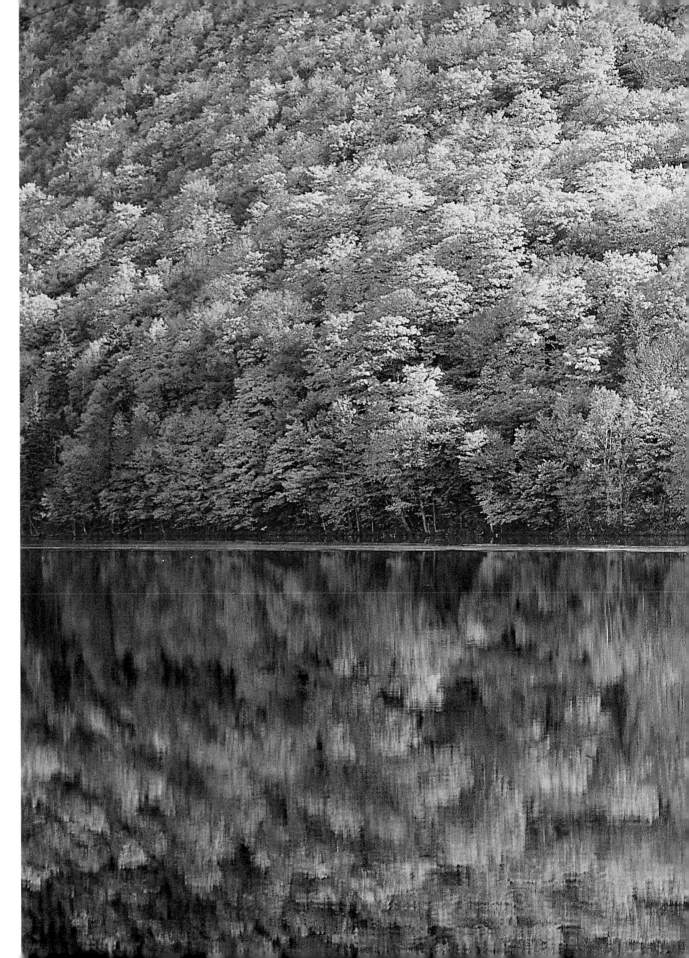

Sheltered by forested hills, Lake O'Law Provincial Park in the Cape Breton Highlands has boating, swimming, and picnicking facilities. Lakeside cottages make the area a perfect summer vacation destination for Nova Scotia families.

OVERLEAF
Just north of Ingonish, Mary Ann Falls provides a scenic resting point along the Cabot Trail. In winter, when most visitors have retired to warmer climates, the falls are left to the moose, deer, and otter, as well as occasional cross-country skiers following the groomed 11-kilometre (7-mile) trail from Black Brook past the falls to Warren Lake.

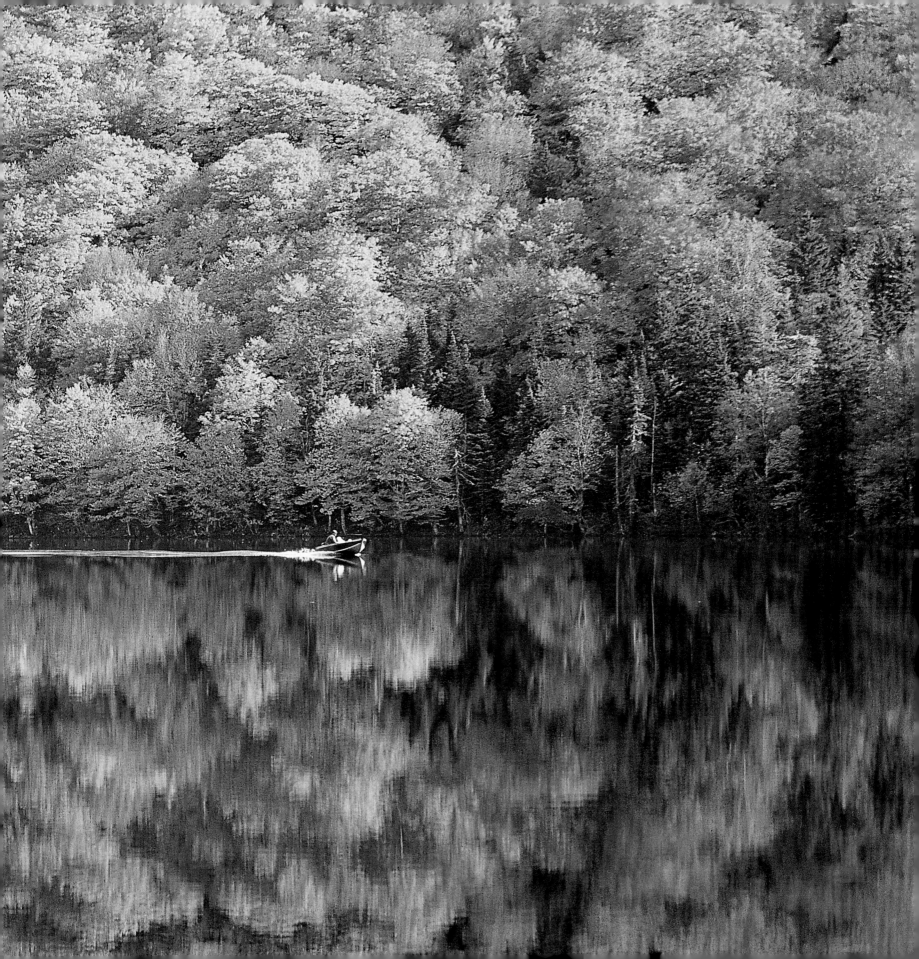

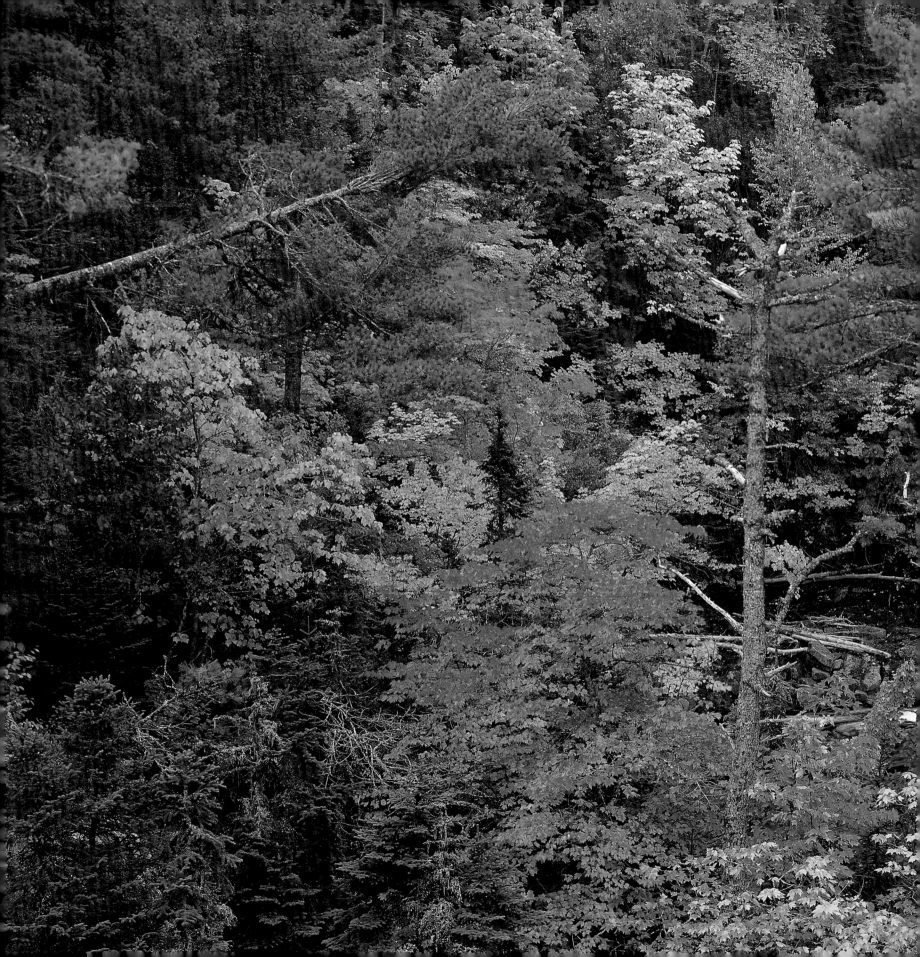

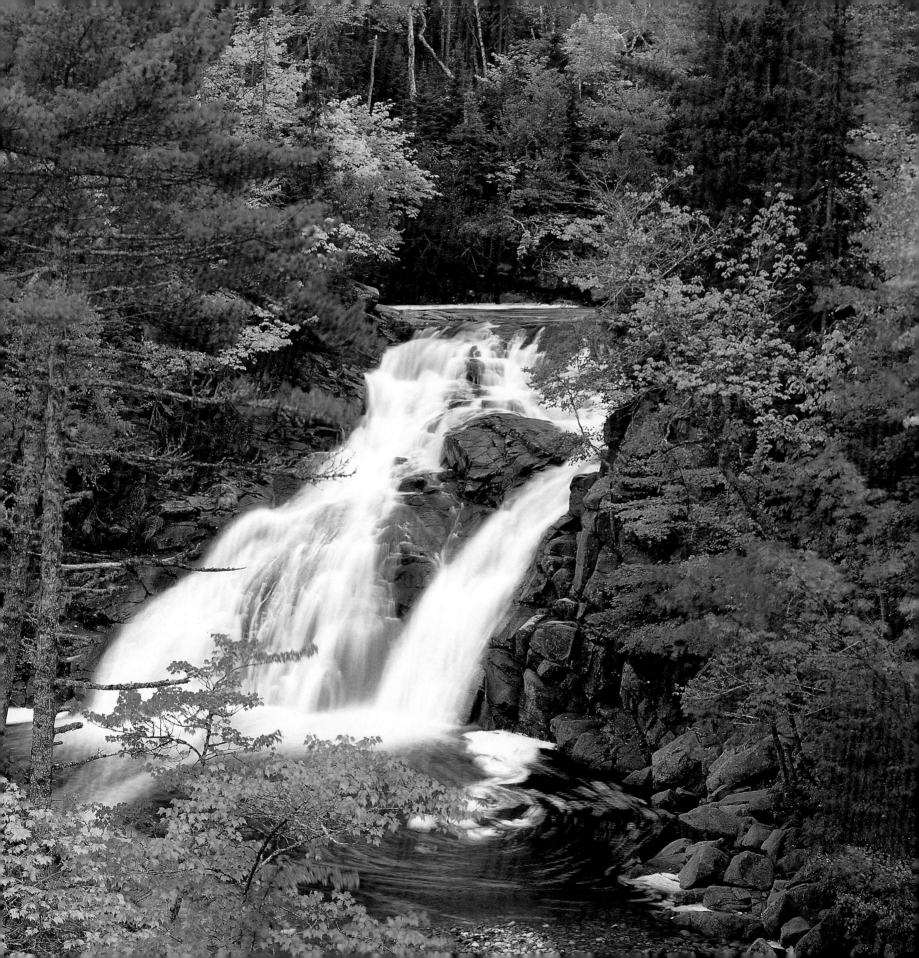

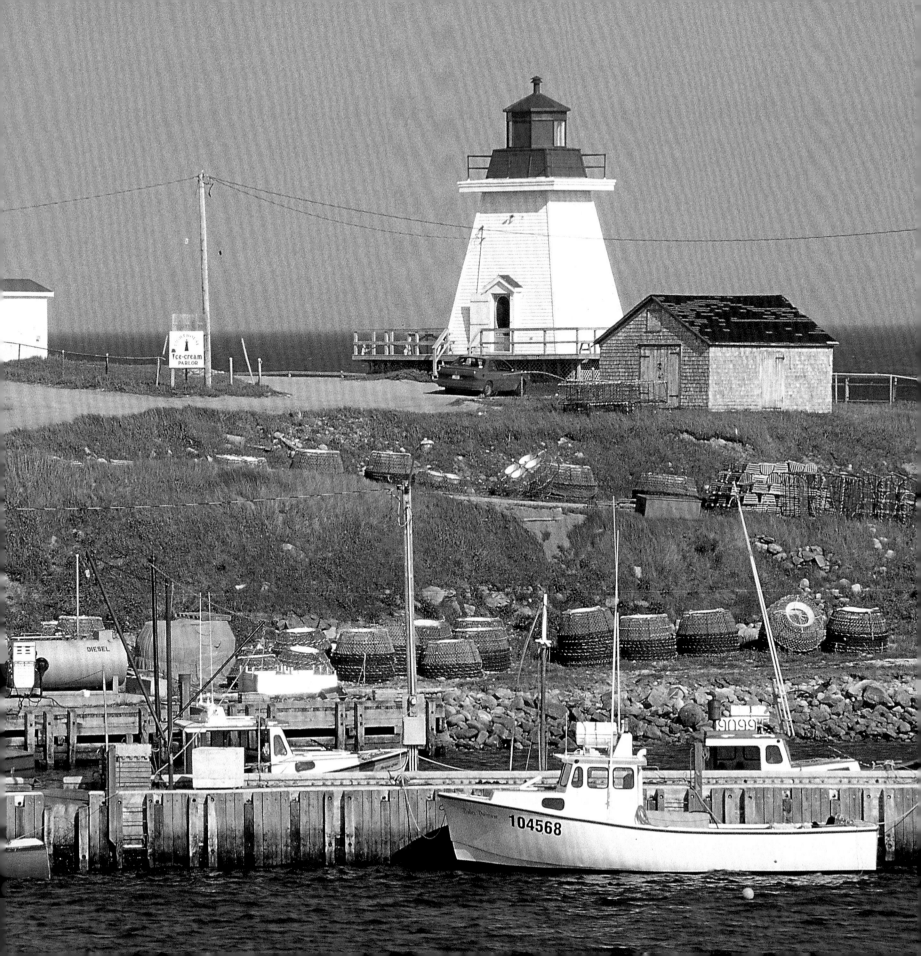

Alexander Graham Bell's invention of the telephone was already paying dividends in the 1880s, when he began spending summers with his family in Beinn Bhreagh on Cape Breton Island. Here, he experimented with sound transmission, medicine, and flight. Alexander Graham Bell National Historic Site preserves the inventor's summer home and commemorates his achievements.

Sea anemones, sponges, lobsters, urchins, and crabs are plentiful in the waters of Neil's Harbour, making this a popular stop for scuba divers. For advanced divers, there are also sea caverns to investigate.

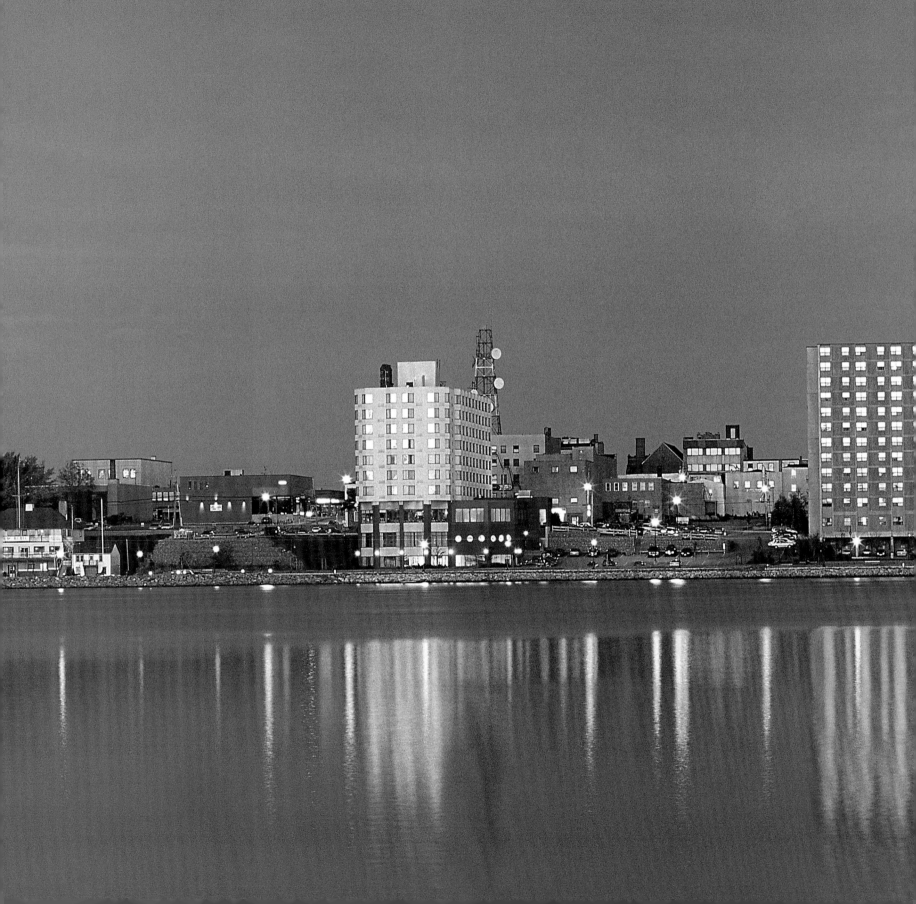

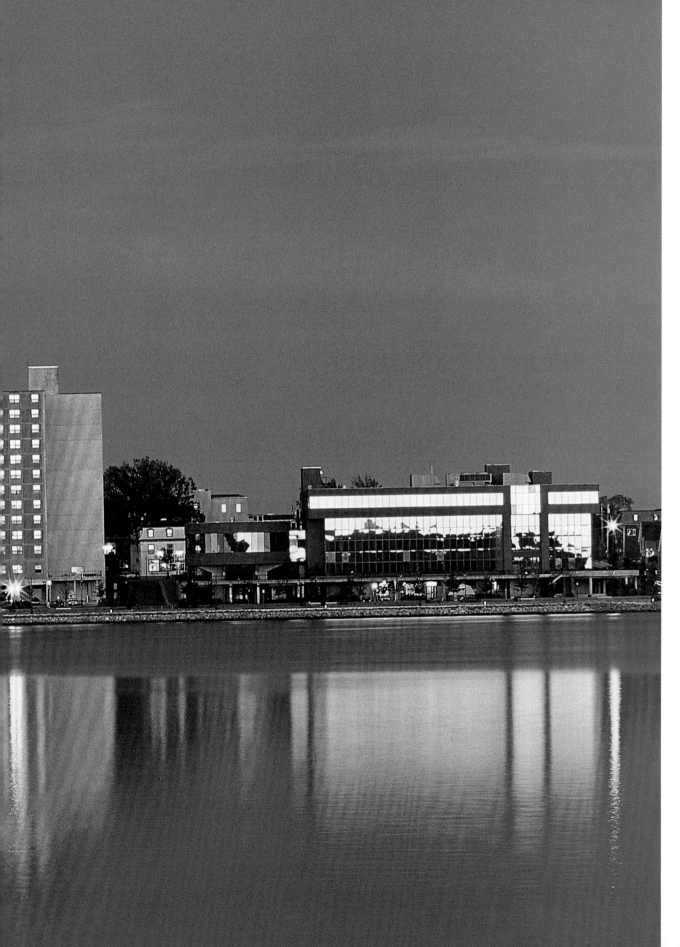

In the late 1800s, a group of financiers including Henry M. Whitney bought and consolidated the small coal-mining operations of the Sydney region, with plans to export the coal to central Canada. The same men also founded the Dominion Iron and Steel Company, establishing Sydney as one of the province's leading industrial centres.

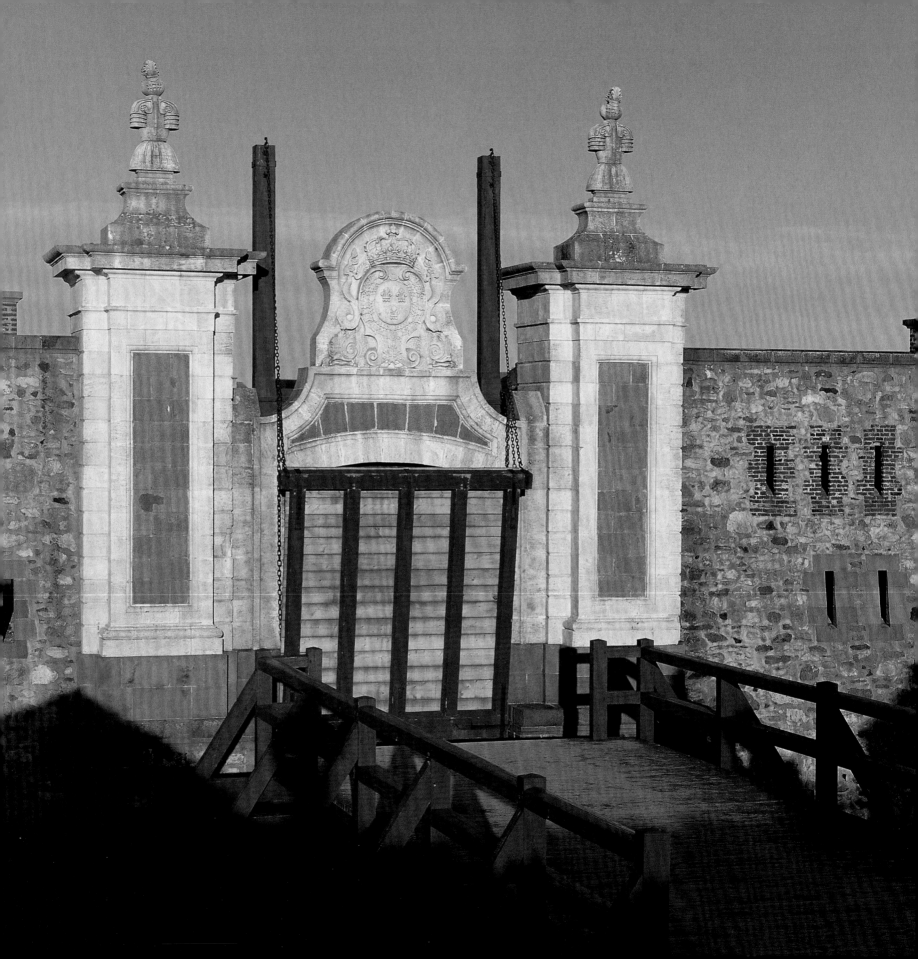

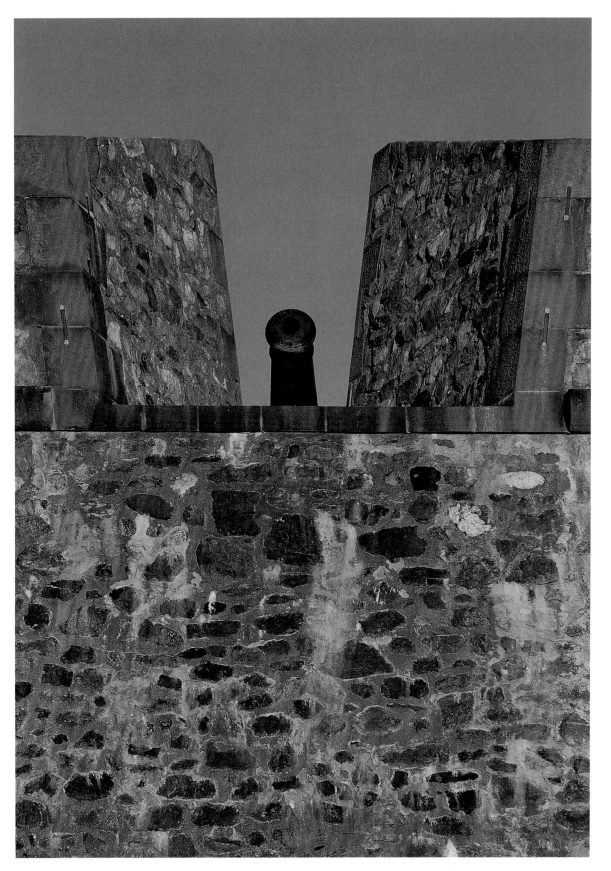

Cannons defend the ramparts of the Fortress of Louisbourg National Historic Site, a reconstruction of the eighteenth-century fortified French town. Within the walls, 100 costumed staff introduce visitors to life as it was in 1744, demonstrating gardening, dancing, lace-making, and cooking over an open hearth.

FACING PAGE
French colonists arrived in Louisbourg in 1713, using the settlement as a base for their cod fishery. As Britain struggled for control over the region, the fort was successfully attacked twice. It fell in 1745, only to be returned to the French by treaty three years later. When English forces recaptured Louisbourg in 1758, they destroyed the walls to prevent any future use of the fortifications.

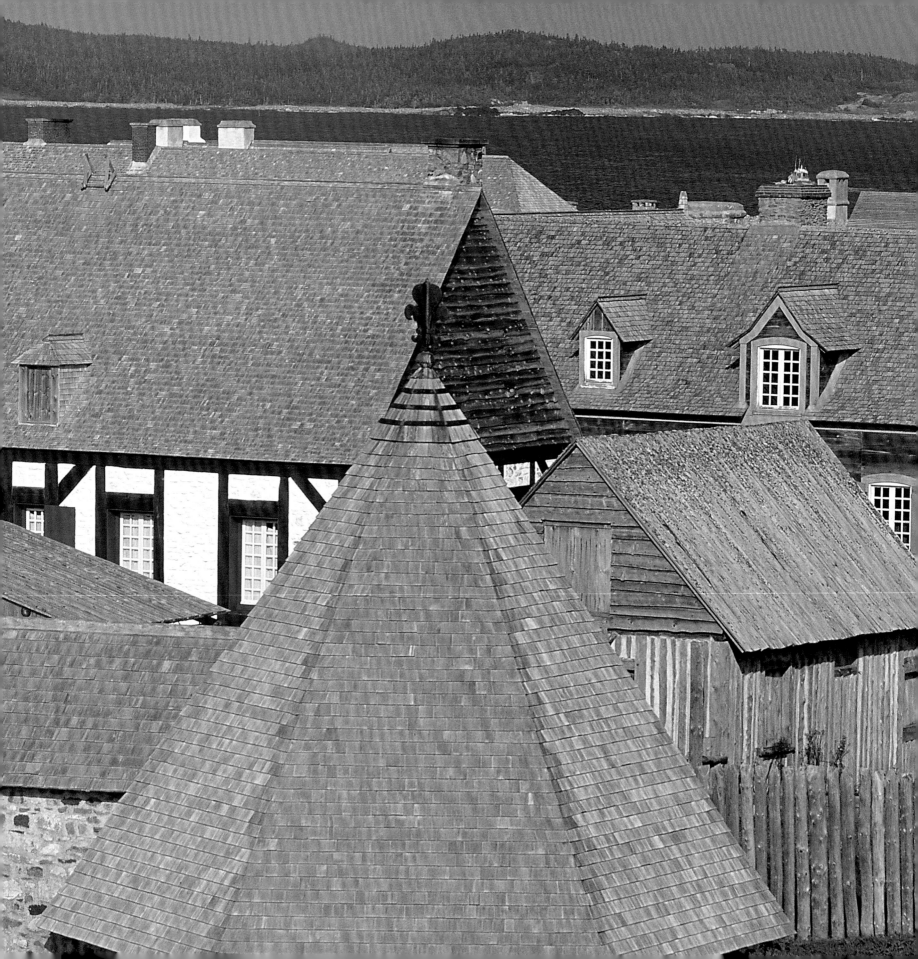

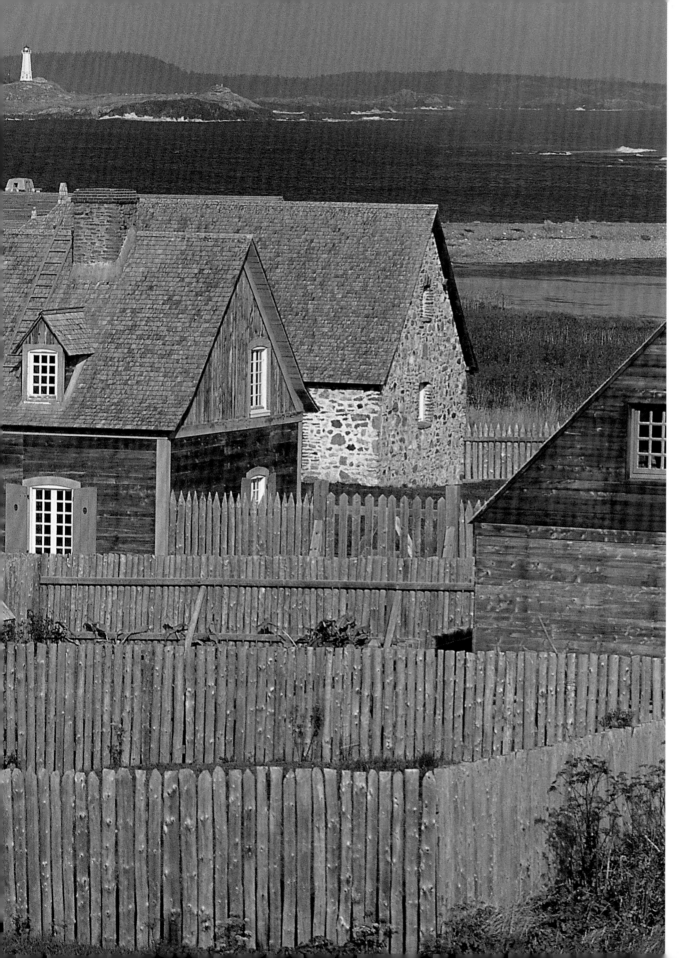

The Canadian government began reconstructing the Fortress of Louisbourg in 1961. To ensure authenticity, archaeologists and historians studied the remains of fortifications and buildings within the town, as well as 750,000 document pages and 500 maps from archives in Europe and North America.

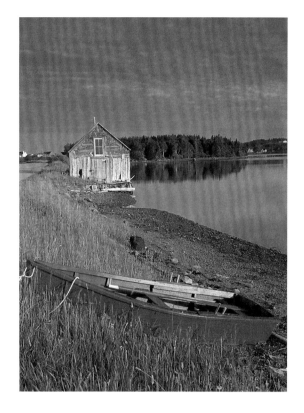

Despite the decline of Atlantic fish stocks, many families still rely on the sea for their livelihood and Nova Scotia remains the industry's leading province. Shellfish such as lobster and scallops now comprise almost half of the commercial catch. Some fishers have diversified, exploring aquaculture and sport fishing opportunities.

Remnants of winter ice float near Arichat on Isle Madame, just south of Cape Breton Island. Abundant fish and an influx of immigrants made the island an ideal trading post in the 1700s, serving American and European vessels. By the mid-1800s, more than 6,000 people lived on the island.

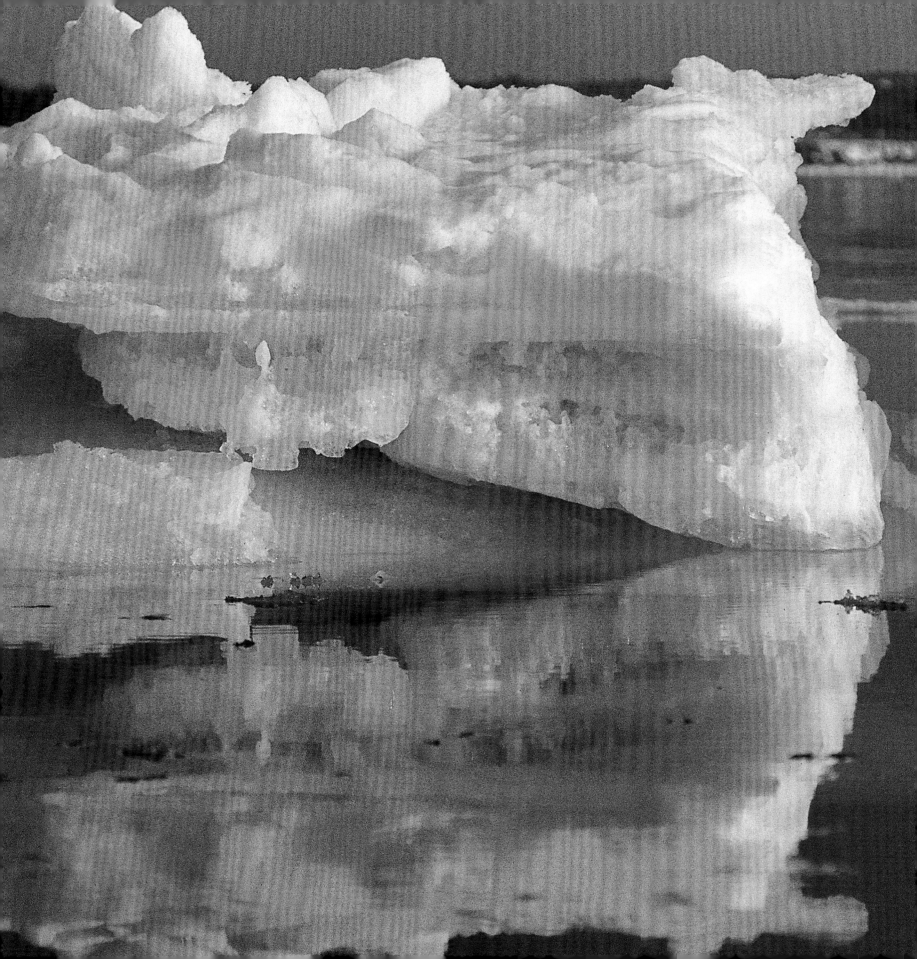

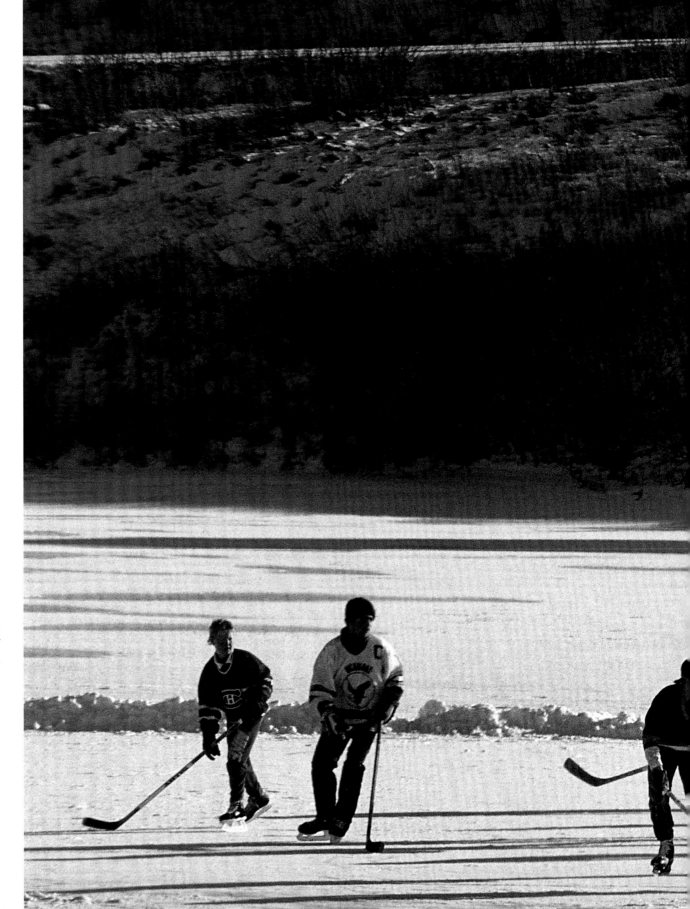

In the 1860s, Arichat's port was so busy that Spanish, French, and American diplomats were posted on the island. The town boasted a cathedral, a courthouse, a newspaper office, and 24 wharves. Today, the community's lively character and historic attractions draw tourists from around the world.

94

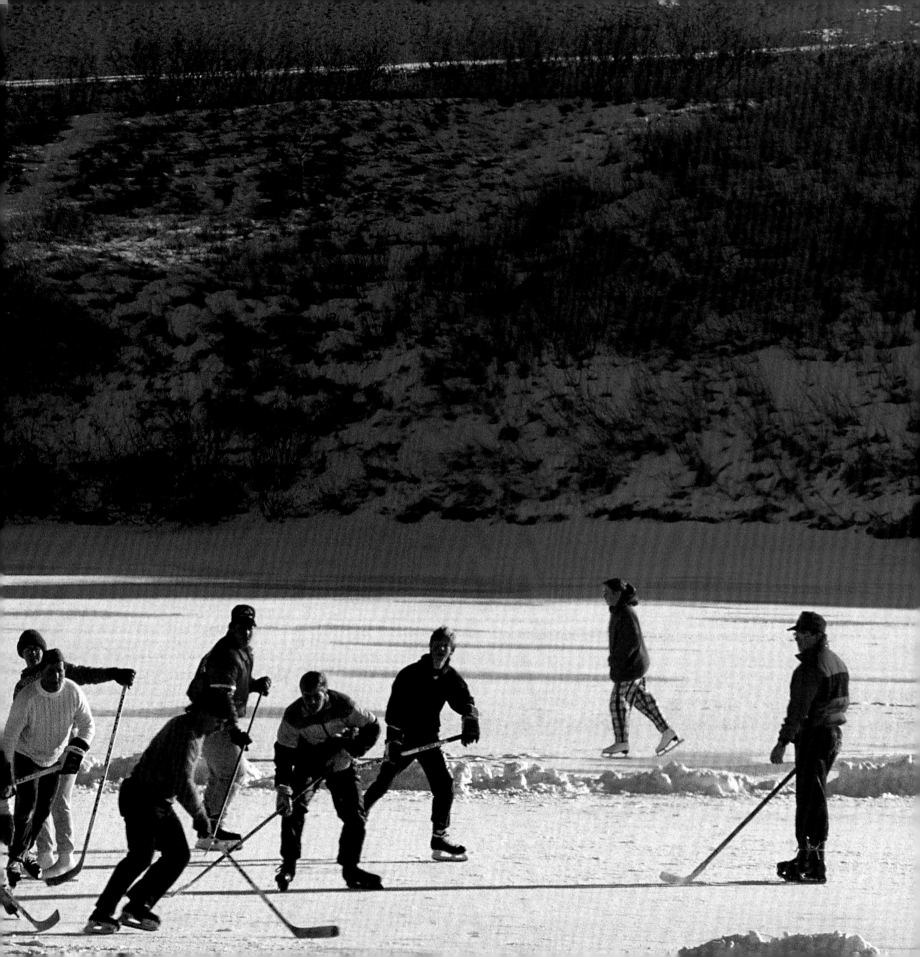

Photo Credits